KU-204-266

MISC 8510

DEPARTMENT OF EDUCATION AND SCIENCE

Art in Secondary Education
(11 to 16)

WITHDRAWN

NEWMAN COLLEGE
BARTLEY GREEN
BIRMINGHAM, 32.

CLASS	375.7
ACCESSION	81841
AUTHOR	GRE

N 0026098 3

LONDON HER MAJESTY'S STATIONERY OFFICE

© Crown copyright 1983
First published 1983

ISBN 0 11 270535 9

Preface

Art is one of those aspects of the curriculum which over the last 25 years have come nearest and most generally to happy revolution. In art the outcomes of learning are the same as or very similar to those outside education in the adult field of art, the crafts and design. There are known stages of performance, there is often competition and often cooperation. Above all, the pupils at work in the art studio are major contributors not passive recipients: they carry responsibility.

In this book HMI describe what they believe to be good practice in art in 14 schools. They record the variety of approach they found and comment on what schools with good practice have in common. They aim to give those inside and outside the education service a view of what is possible in the subject and help those engaged in schools to bring about an improvement in their own practice.

Contents

Some of the chapters which follow describe
a single art department, others bring
together descriptions of several which seem
to have features in common, or concentrate
more narrowly on the work done with
individual teachers.

Introduction

This publication describes the work of a selection of art departments in secondary schools in England seen during 1981 and 1982. HMI, in consultation with specialist local education authority advisers, drew up a long list of schools where lively work and good teaching were thought to exist. Many of these schools were visited and of them 14 were revisited by HM Inspectors working in pairs. The object of these extended visits was to attempt to answer the question, "Is this a good art department?" and then to ask "If it is, what makes it so?"

This book is therefore an enquiry about quality by means of selected examples and follows an earlier publication, *Art in junior education*, which for the first time brought together examples of good practice in the junior age range. That publication, together with the Schools Council bulletin on art 7-11 and the LEA art advisers' exhibition and booklet on "Learning through drawing" revealed an unusual, and in some ways surprising, consensus about the purpose of art education in the junior school.

Art in secondary schools is more complex; it is among those subjects in the secondary curriculum concerned with the pupil's aesthetic development and involves work in one or more of many materials and techniques – for example painting, drawing, print-making, ceramics, textiles, constructions or photography. In some art departments it may be an activity stimulated by the need to solve problems as in the work of a designer; it may be practical, making something new or original; or it may be contemplative, enjoying what already exists; it may be an individual or a group activity, on the minute scale of jewellery or on the large scale required for stage scenery.

On average, art is included in the curriculum of all pupils in the first 3 years of secondary schooling, and in the fourth and fifth year almost 40 per cent of pupils continue to study it. In the sixth form almost 15 per cent of pupils study art for Advanced GCE in addition to those taking O-level courses and art in liberal and general studies. Some will leave at 16 and take art in further education and some of the sixth formers will enter higher education and later become artists, designers and craftsmen. It is estimated that in 1982 approximately 300 000 fifth form pupils, who completed courses in art departments of maintained secondary schools in England, were entered for public examinations in art, the crafts, design, the history of art and the history of design.

Most secondary schools have at least one studio and a trained specialist art teacher. Some have large art departments staffed by teams of specialists who offer a range of expertise; some art teachers are highly directive, others are not; their backgrounds and training are often very different. It is to be expected that there would be great variety in practice and in the underlying principles of art education which inform it.

The final choice of schools described here attempts to reflect that variety of approach. For example, some of the present debate among art teachers centres on the relative emphasis given to making and doing art on the one hand, and learning about art on the other. Examples are also included of the quite striking variety of circumstances in which art education takes place. In one of the schools, pupils work in one minimally adapted room; in nine of the others they have the benefit of working in suites of studios with everything to hand. In one of the four schools in deprived areas, the art room is an oasis of colour in an otherwise dispiriting and wearing environment.

The schools range from a recently built maintained comprehensive school in a new town to a major public school in a rural

setting. The effectiveness of art departments – and indeed any department in a school – is powerfully affected by the attitudes of the head and the management skills of the head of department. Our choice of schools shows a variety of such influences at work.

This, then, is by no means a description of 'top' art departments. If there had been room, many more of equal quality could have been chosen to demonstrate a range of alternative practices. Although the notion of 'good practice' itself inevitably implies criteria, none of the visits was made with a strong preconceived view of precisely what should be going on in school art departments. Nonetheless the series of visits did provide a set of experiences which led to a crystallising of our view of what schools with good practice have in common, and this is discussed in Chapter 8. Not everything will be applicable to all schools but readers will find there suggestions which may be useful in attempting to improve the quality of art education in their own schools.

The Schools

School 1 Brinkburn School in Hartlepool is an 11-18 mixed comprehensive, with 1400 on roll. It became comprehensive in 1973 and is maintained by the Cleveland local education authority. The school occupies three separate sites one of which, a former elementary school, houses the department of creative arts. This old three storey building, over a mile from the main school, has been very well adapted for art, home economics and CDT. The art department occupies the first floor and there are four full-time art teachers. The head of art is also head of the creative arts department.

School 2 Padgate High School is a recently built 11-18 mixed comprehensive in the rapidly growing New Town area of Warrington and is maintained by the Cheshire local education authority. At the time of the visit the first intake had reached the fourth year and there were two full-time art teachers and 850 on roll. The school serves an area which includes housing built in the thirties, fifties and sixties. New pupils of all ages arrive at the school each week as families move into the new town private and corporation estates. There is joint use with the community of the library, drama and sports facilities. The art department has been growing in size with the pupil numbers. As the first intake reaches the sixth form a third full-time art teacher has been appointed and a third teaching space brought into use.

School 3 Brentwood High School is a former grammar school for girls and was reorganised in 1972 as an 11-18 mixed comprehensive. There are 1300 pupils on roll including 160 in the sixth form. It serves a mainly residential area and is maintained by the Essex local education authority. The art department is part of a creative studies faculty which also includes CDT and home economics and the head of art is also head of the faculty. The four spacious art studios were purpose-built in 1975 and include facilities for drawing and painting, ceramics, printmaking and textiles. There is also a photographic dark room and another room without windows, which is used to house the department's large collection of still life objects. There is a library reference area with a carpet and chairs which the pupils use and an office for the art staff.

School 4 Cansfield High School is a former secondary modern school which became an 11-16 mixed comprehensive in 1978. It is maintained by the Wigan local education authority and there are 1200 pupils on roll. It is situated in Ashton-in-Makerfield, a former mining area which has become a commuter district because of inexpensive housing and the proximity of a major motorway. The art department consists of four areas in an open-plan suite; with store rooms in the centre. It is in the middle of the main school building and has no external views except onto tiny courtyards walled in drab concrete. Its equipment has been well chosen by the local education authority. There are four full-time art teachers.

School 5 Leyton Girls' School is a social priority school, situated in an older suburb of North East London. It became a 14-18 comprehensive school for girls in 1968 and is maintained by the Waltham Forest local education authority. There are over 700 on roll, 130 of whom are in the sixth form and slightly less than half of whom are from ethnic minority backgrounds. It is in a former grammar school building which has been extended for practical subjects including science, art and home economics. The art department is on the top floor of the practical block and consists of an open-plan area divided into four bays, by walls and movable furniture. It is spacious and attractive in appearance with good display facilities and has been well equipped for drawing, painting and ceramics. The staff have themselves, with the help of a technician, improvised equipment for printing. There are three art teachers, one of whom is part-time.

School 6 Royal Forest of Dean Grammar School is an 11-18 mixed grammar school with 760 on roll, maintained by the Gloucestershire local education authority. It serves a large rural community of scattered villages and small towns of miners' terraced cottages. The arts have a strong place in the school. In addition to optional examination courses in the arts in the fourth and fifth year, non-examination courses in music and either art or drama are compulsory for all pupils in the fourth year. There are substantial extra-curricular activities in the arts. Accommodation for art is in a large, L-shaped room, with three teaching spaces, two of which are used for drawing, painting and printmaking, and one for ceramics. There is one full-time art teacher, one who teaches both art and PE (60 per cent and 40 per cent) and a part-time teacher of ceramics for two days per week.

School 7 Marlborough College is an independent school in Wiltshire with over 870 pupils on roll. Boys enter the school at 13 and girls enter in the sixth form. All pupils have art for two periods per week in their first and second years (third and fourth); options are introduced in the third (fifth) year and art may only be taken in "voluntary choice" time. This being a boarding school, voluntary time is substantial and on average 75 boys choose to study art for GCE O-level. It is worth noting that a quarter of the sixth form (50 in lower and 50 in upper sixth) take GCE A-level art and exceptionally large numbers of pupils gain places in colleges of art and design every year. The art department is modelled on the design of a Hawksmoor church and contains seven teaching spaces for practical work, study and discussion. Work done in this building is mainly drawing, painting, printmaking and design; ceramics and jewellery being done in two adapted cottages nearby. There are seven art teachers, two of whom are part-time.

School 8 Haugh Shaw Secondary School is a two-form entry mixed secondary modern with 380 on roll. It is situated in Halifax and is maintained by the Calderdale local education authority. Originally a Board School built in 1879, it was modernised and extended in the early sixties and seventies. The art room is a former hall and is very high and spacious. There is one full-time art teacher.

School 9 Backwell School is a mixed 11-18 comprehensive with 1400 on roll. It serves both a rural and urban population near Bristol and is maintained by the Avon local education authority. The school, which became comprehensive in 1969, is housed in a number of buildings spread out over a large site; the art department is on the ground floor of one of these, containing four large studios which have been adapted for drawing, painting, printmaking, textiles, jewellery and ceramics. A single-storey temporary building alongside the art department has been converted for photography. The local education authority has given approval to the alteration of the studios by the art staff, and provided architectural advice. There are five full-time art teachers. In the fourth and fifth years 65 per cent of the year groups opt for art and take courses leading to GCE O-level in art and ceramics or CSE in art, photography, jewellery and ceramics.

School 10 Chesterfield School is a 13-18 comprehensive school for boys with nearly 800 on roll. It became comprehensive in 1974 and is maintained by the Derbyshire local education authority. There is an emphasis on academic achievement and this is one of two single-sex schools taking pupils from seven 11-16 schools in the area. The art department is a U-shaped space adapted from two former classrooms and a store, with facilities for drawing, painting, ceramics and textiles including tapestry weaving. There are two art teachers, one of whom is part-time, and some ancillary help. To match the unusual combination of art, craft and design to be found in drawing,

painting and tapestry weaving, the department offers the Joint Matriculation Board GCE O-level Art Scheme B. This examination gives 50 per cent of the marks to internally assessed course work.

School 11 Didcot Girls' School is an 11-18 comprehensive school with 1000 on roll. It became comprehensive in 1973. The school, which is maintained by the Oxfordshire local education authority, is housed in three buildings spread out on a large site in the middle of a housing estate. The art department has studios in two of the buildings and maintains displays of pupil work in all three. There are facilities for ceramics, drawing and painting, including mural and other large scale painting, and there are three full-time art teachers.

School 12 Fred Longworth High School is an 11-16 mixed comprehensive in Tyldesley and is maintained by the Wigan local education authority. It became comprehensive in 1976 and is housed in new buildings situated in an industrial wasteland. It has 18 contributory primary schools and feeds a tertiary college. The art department is unusually well represented in national art exhibitions. It is part of a faculty of creative studies, which also contains home economics and CDT. There are four art teachers who work in one large, well equipped studio, measuring approximately 60 feet by 90 feet assisted by a faculty technician for part of his time. There are facilities for drawing, painting, ceramics, printmaking, textile printing, three dimensional design and sculpture. In addition to the art staff, a teacher in the home economics department, who is an embroiderer, works in a room between home economics and art, where there are facilities for batik, dyeing, embroidery and weaving.

School 13 Washington School is an 11-18 mixed comprehensive with 1400 on roll and is maintained by the County Durham local education authority. It became comprehensive in 1969 and is situated in an old mining village which now forms part of a New Town. The original building of 1909 has had substantial additions in the thirties, fifties, sixties and seventies. The art department occupies the top floor of a CLASP three-storey building, and a ground floor suite of rooms for three-dimensional work. There are four full-time art teachers.

School 14 Rye Hills School is an 11-16 mixed comprehensive of over 1000 pupils in Redcar and is maintained by the Cleveland local education authority. The school became comprehensive in 1975 and occupies two former grammar and modern school buildings on the same site. The art department is situated in a well-equipped suite of rooms skilfully adapted from a former gymnasium and changing rooms. The suite consists of four studios, semi-open in plan with a central library area. A comfortably furnished gallery at the end of one studio is also used for discussion. The library area contains books on fine art, crafts, photography, industrial design, textiles, furniture and architecture; there is also a range of art and design periodicals and information on careers. There are four art teachers, one of whom is part-time.

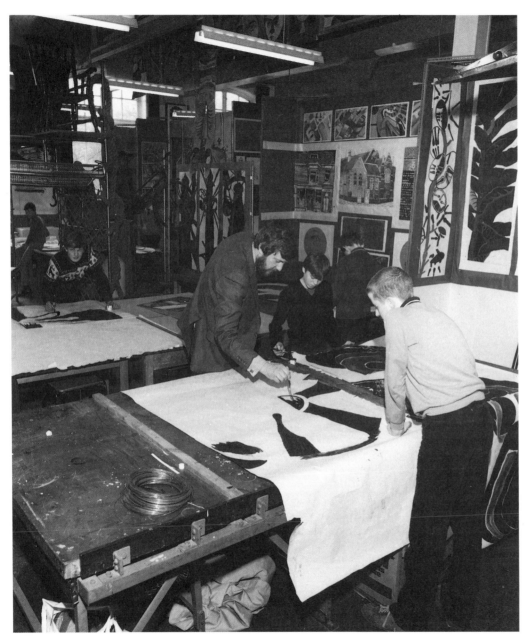

Below School 1
Displays of unusual objects are used to stimulate
the imagination as well as provide material for
drawing.

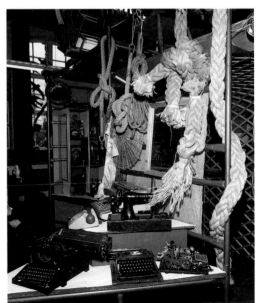

Chapter 1 "It won't paint itself!"

The department of creative arts in school 1 is in an old elementary school building set apart from the main school by over a mile. The art department is on the first floor between home economics and craft, design and technology. The grim external face of the building contrasts with the clean, light and airy interior. Visitors to the department are confronted by displays of honest and realistic work by the pupils, in a variety of media, about the place that they live in, the ideas that they have and the things that they feel.

There is an open-plan studio, which has been adapted from a hall, divided in two by screens, which are grouped together and fitted with castors so that they can be easily rearranged. Both areas thus created are multi-purpose; at one end facilities exist for print-making; a small studio contains excellent specialist facilities for screen and block printing. Another small studio is reserved for the use of the sixth form. There are ample work surfaces for all purposes and efficient storage and display. Much of this has been made in the department or adapted from surplus items elsewhere in the school.

Work is displayed on all surfaces, even the beams of the ceiling. It is well mounted, with fine attention to proportion, colour and placement; and is in constant use as a teaching aid. The displays contain material not always for immediate use as sources for drawing – but there to provide a stimulus for the imagination. An eight-foot length of large diameter rope, a group of knotted rope ends and raffia, a wire rack of odd shoes of many styles and colours, crab shells, boot polish tins, ink bottles, some ancient picture bricks, an old padlock, a baby's rattle, a spring, a bundle of model railway track, gears and many other items are to be seen on shelves and surfaces throughout the studio.

Behind the scenes in an alcove formed by screens is a reserve collection. Many objects and materials are categorised, labelled and stored with precision. An Aladdin's cave, with all items readily to hand, identifiable and systematically organised. The visual and tactile environment is exciting, but as well as fulfilling serious intentions, the studio is also fun. One screen has a full-sized trompe l'oeil painting of a partially opened door. A life sized convincingly painted cut-out of the teacher stands disconcertingly in a corner. A line drawing of a full-sized figure has been painted on a window to the department office, apparently tapping the glass and staring out.

Surprise is a part of the teachers' stock-in-trade. In this room among the displays are grotesque masks, large figures of Mickey and Minnie Mouse, both dressed – Minnie in an old fur coat; carefully made and funny. One wall is devoted to the theme of "silver" (the word itself cut out in polystyrene letters three feet high and painted silver) projects in front of a surface about ten feet square which is made up of dozens of saucepan lids, hub caps and baking tins. A silver painted wheel and tyre hang above it. Towards the centre of the room this theme continues with car wheel trims and hub caps hanging like a series of mobiles from the high ceiling. A display of glass on open shelves by a window focuses on their silhouetted shapes.

There is a serious concern that work should relate to the local environment and life outside the school. Referring to the working displays of objects in the studios, the head of department says:

> "That's one of the reasons why all the junk comes in; it brings the outside world into the school".

Pupils habitually work in the town; observing, questioning and drawing. Many designs, paintings, prints and constructions originate from such study. There is also a concern to establish a close relationship with the community. Pupils are involved in producing posters and displays for local and regional events and in other local art projects. The department mounts exhibitions of pupils' work, in the local art gallery and a disused church in the town square, which are always well attended. It is considered important, especially in an area of traditionally high unemployment, for pupils to receive public recognition of their achievements.

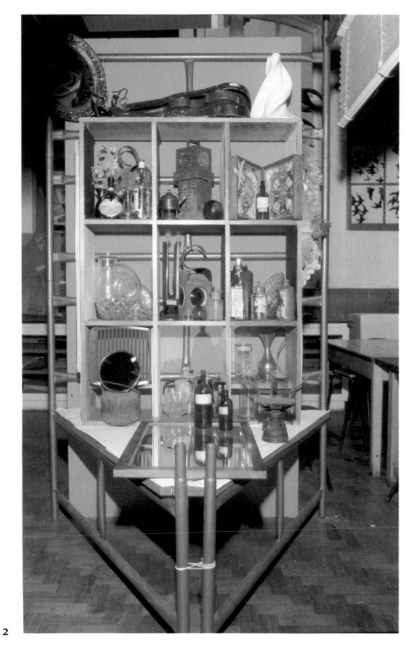

Left School 1, 3rd year
Painted Sculpture

Far Left School 1
Displays of unusual
objects are carefully
arranged to stimulate
the imagination as
well as provide
material for drawing.

Two rooms on the ground floor have been joined to form a pottery workshop. There are few "pots" to be seen but architectural themes have provided the source of inspiration for modelling. There are models of pupils' homes, churches, and fantasy structures. Some are over two feet high and have to be divided to fit into the kilns.

First year pupils are making pinch pots and joining them together to form animals. They are obviously used to the careful and clear instructions that the teacher gives and they work purposefully and independently. Towards the end of the lesson the teacher gathers the group together to ask each to make a small piggy bank, using the same methods, to be sold to raise funds on a

School 1, 5th year
Much of the work involves close observation.

coming parents day. Holding a finished piggy bank up for the class to see she asks:

"How much shall we sell these for?"

"£1.50 Miss"

"Would your parents pay that?"

"Yes, Miss"

"Why, it seems a lot of money for a bit of clay?"

"But they are hand made, Miss, and they are unique."

"Good; bring your parents along and we will see what they will give us. Put your names on all your pots, wrap them well and bring them to the front bench."

The class clears up in a disciplined way. All bench tops are scrubbed, sponged and wiped down. Modelling tools of assorted shapes and sizes, old kitchen knives, tooth

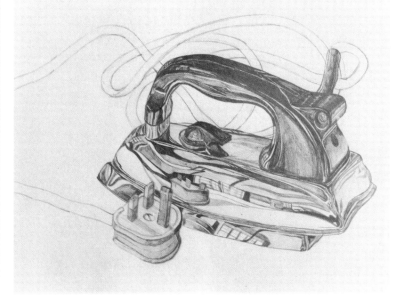

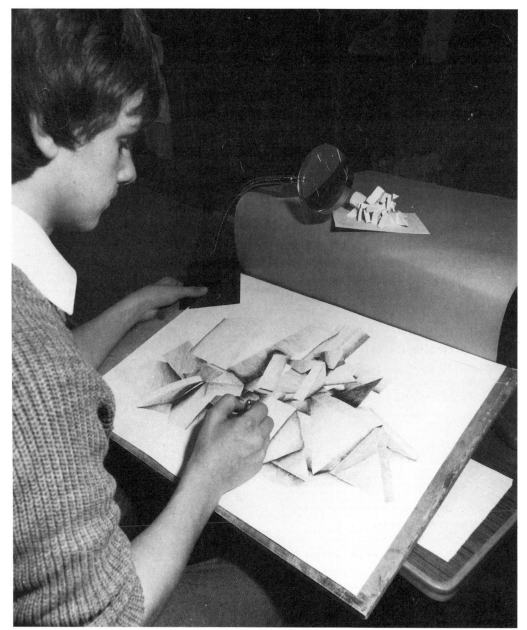

brush handles and pen holders are washed and replaced and the class sits down before leaving. The floor is checked for clay. The work is then examined and discussed, the teacher taking individual pieces carefully and questioning individuals about their ideas and intentions.

Later, amongst a class of fifth formers, some complain that they are not going to be potters and that there is no real reason for them to pursue the course. The teacher however takes a positive line and suggests that whatever the boys and girls are going to do, prospective employers would be interested in seeing what they have done, particularly if they have been working with their hands. Some pupils going for interview have taken their pots with them, and this is said to have been helpful in providing an opportunity to talk about what they know, and show that they can think and translate their thought into action.

Upstairs the head of department is teaching a fourth year CSE group of about 25 boys and girls. They are finishing large portrait drawings begun in a previous lesson. The original idea came from a newspaper article on plastic surgery. Discussion about slicing through forms is developed by cutting through photographs, and combining male and female features. A line of questioning is introduced which leads eventually to an examination of multiple

School 1, 4th year
Care is taken to give the pupil every advantage when drawing, such as the careful arrangement of the drawing surface and the position of the objects being drawn.

4

viewpoints of a Picasso painting and discussion of Cubist ideas about form. Half the class is invited to hold up their drawings. These are large (A1 size) on brown wrapping paper using soft pencils. Three pupils are selected and remain standing, holding their drawings, whilst specific points are made to the rest of the class. It is suggested that the shapes should be made more definite by working into them with other smaller and more complex shapes. Discussion about tonal control and how it can be used for effect is developed. One pupil has cut a small crescent stencil from a piece of scrap paper and by shading across it she has built up a hair pattern, while another uses strips of paper as a resist.

The rest of the drawings are then held up. The pupils are in no way self-conscious and the teacher moves back and forth across the studio referring to his own face, the pupils' faces and their drawings. The pupils are referred back to their original collages of a variety of features taken from photographs, composed as an invented portrait. The drawings these pupils are working on are assured, confident and personal, but they are challenged about the next step when they feel they have finished. To sharpen lines and make better edges to shapes, they are shown how a piece of paper can mask some areas while shading across others. Drawings by two pupils from the other half of the class are used to show that these large portraits in pencil are nearing completion, but most people need to look more carefully for small shapes and strong contrasts. Pupils return to work, consult their original designs very carefully then reassess their own drawings.

Later on, the head of department teaches a first year group of ten pupils from the lowest ability band. An unusual assortment of chairs has been placed upon the tables. There is an Edwardian swivel desk chair on castors, a turned wooden arm chair, a chair with an interesting curved slat, an ornate arm chair in leather and carved wood with an old velvet cushion and a simple homely kitchen chair. They draw directly onto three feet by two feet white millboards (free offcuts from a local source). They have no difficulty in filling these large spaces. His comments to this group are simple.

"Don't draw the little bits and then find you can't fit it all in, or that it's too small". "Big, big, big, big – don't get too small, start down here, and make it go right across from there to there." Then handling the foot of the desk chair

"See this line here . . . big, simple line". ". . . put that in, and that, and that and that, then counting the legs of the chair, 1, 2, 3, 4 put them in and you can see if it all fits. See how round it is there".

A boy, drawing the desk chair, has already got a simple, clear, well-constructed drawing entirely filling his card. "It's hard!" he says, looking at it intensely, sensibly self-critical. "This foot isn't quite right yet, it needs to be at this angle."

The pupils refer to how much they enjoy looking at the work on display as they draw, saying that it is different every week. "I want mine to look like that" says one girl pointing to a strong vigorous painting. The work on display acts as a silent example and sets standards.

"It's not a straight back. When you sit on

it it fits your backbone. See, – what shape is that? What angle?"

And so understanding develops and the drawings evolve from simple beginnings to a complex record of the forms of the chairs. He holds up a chair against a projection screen, kept ready for use, to show more clearly the pattern of the spaces. He then talks about colour, describing its subtlety, looking closely into the dark masses of wood; finding blues, purples, oranges.

Some pupils are, by then, painting. They use dry powder colour in trays of eight or ten large metal containers made by the school from food cans. These have been welded to a metal base. The pupils look carefully and

School 1, 4th year
Pupils try alternative colourways in screen printing.

5

match colours skilfully, subtleties are seen and recorded with accuracy and paint texture exploited. Their palette consists of a warm red and a cool red, two blues, an ochre, a lemon, a black and a white. They hold their brushes well back on the handles and most stand up to see their work; some work with boards flat and others at an angle.

These pupils, considered by the school to be of limited academic attainment are challenged and they achieve and enjoy achieving. They have no time to become bored, all are producing work of value. A girl in this group was shortly to have a painting accepted for the National Exhibition of Children's Art. She, together with the other exhibitors and prizewinners from the school, visited the exhibition in London and was impressed to see her photograph in the local paper.

In the other half of the open-plan studio, divided by ten feet high display screens, the other teacher has another first year class. Each of these pupils has a section of a retort clamp to draw, held at a suitable angle by a lump of plasticine. They draw first in pencil a much enlarged image on grey tempera paper; then in black and white crayon. They are aiding their ability to see by looking through sheets of coloured gelatine, thus clarifying the tonal pattern. A pupil patiently explains how this is used to simplify tones and subdue highlights.

In both classes the work is consistently good and some is of an excellent standard. Attention to the task in hand is complete; understanding is sound and enjoyment evident. Clearing away is quiet and efficient, no instructions are needed and they all know exactly what to do. At the end of the lesson the pupils are asked for homework, to collect together for next week some fabric — lace, stuffing, beads and string — in various colours and sizes. This is to be used as material for the following week's homework. The headmaster joins the teachers for coffee, as he often does, in the department office. He is friendly, appreciative and very proud of the achievements of his art department.

Art is well supported as an option subject across all ability bands and many pupils from the lowest ability groups choose to study art. There is consistently high expectation of what they can achieve. In discussing preparation for public examinations, the head of department says, "Our core of work just goes straight on and we direct for the examination when we reach it." He does not feel the need to teach to an examination syllabus but examination results are always outstanding. These high expectations of the staff coupled with the hard work of teaching have achieved much success in this school as reflected in the examination results. Out of 240 in a year group, about 30 of the academically able take O-level art. Approximately 60 take CSE and 50 per cent of these achieve grade 1. Results at O-level are equally good with over 50 per cent achieving grade A.

School 1, 2nd year
Ceramic relief tiles of local houses, made to the same scale, will be assembled to make a mural.

Chapter 2 First-hand experience

It is a central purpose of art education that pupils should learn to look hard at things to the point where the eye sees clearly and analytically. It is one of the art teacher's responsibilities to organise experiences in such a way that their pupils pay close attention to what is in front of them, in contrast to merely glancing. Various techniques are used to catch and hold the pupils' attention, and to make them want to draw or paint. Working directly from objects, plants, figures, interiors, townscapes and landscapes offers many opportunities for developing a sensitive eye and mind, and for gaining a number of skills and perceptions. In all the schools visited, extensive use was made of first-hand experience and in six of the schools particularly, it was possible to isolate a number of teaching skills which led to success.

The quality of the created environment and the selection of learning material
The first group of teaching skills is concerned with the arrangement of work spaces and the way in which the careful choice of objects, and the manner in which they are displayed, enables the teachers to engage and intrigue the pupils.

● The first impression in school 2 is of a kind of comfortable order, rich in displayed objects, not fussily placed but disposed by someone with an artists' eye for contrasts of colour, scale and texture. On shelves and running benches are plants, both large and small, alive and dried, coloured majolica ware, shells, baskets of feathers, books, bottles, an old sewing machine and a stuffed mongoose. Many of these objects are taken off the shelves and used during our visit. Pinned to the ceiling are Japanese paper butterflies and large sample weaves, and a number of half or three-quarter size figures in wire and papier maché hang from the walls. Paintings, carefully mounted, are displayed against areas of grey, orange and yellow backgrounds. At the entrance to the art room is a display board used by the teacher in a more personal way, to draw attention for example to some graphic

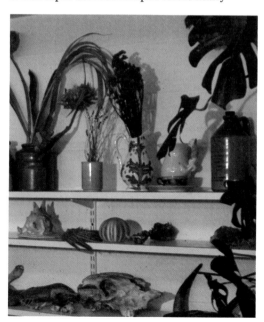

Left School 2
Objects are immediately available for drawing and painting.

Right School 3
Delicate items, secure but visible behind glass

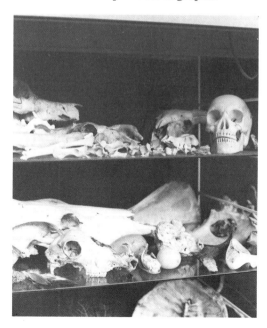

7

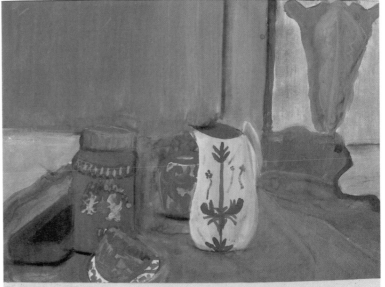

images she herself values, including photocopies of pupils' drawings, greetings cards and reproductions.

An equally valuable, but different environment has been created in school 3, where the staff had asked parents for things to draw and had been inundated with objects including machinery, clothing and utensils. A former projection room was turned into a central resources area to store this material. What at first was a room full of bric a brac has been periodically enriched and refined and is now a collection providing subject

matter worthy of study. The clothing includes a miner's helmet, a complete riding outfit, a judge's wig and gown and a Victorian evening dress. The natural forms include 15 skulls ranging in size from that of a horse to that of a mouse. Much of the collection is being used at any one time in this large department, both by individuals and groups. Regularly with fourth and fifth form classes, a number of objects will be carefully grouped together with some painted furniture, to create scenes which reflect the department's interest in Impressionism and the perceptual discoveries of that movement. Teachers constantly refer pupils to the evidence of their own eyes.

• A girl volunteer (they all 'volunteer' in turn) from the group is sitting on a stool, arms outstretched onto a table; she is holding a chef's knife in her right hand and is wearing a striped apron. A cloth covers the table on which are placed food and utensils. Patterned paper on a vertical board is used as background. Great care is paid to the lighting of the group. The fluorescent lights which subdue subtleties of tone and colour are turned off and the group is deliberately arranged near a single window.

In the next studio a fifth year group of 22 pupils are painting a tea party scene using two girls wearing big hats sitting with a small round table between them, set for an al

Left and below School 2, 3rd year
Working directly with paint, these pupils show contrasting perceptions, interpretations and treatments of objects from the art room collection.

School 3
Part of the extensive collection contributed by parents, pupils and teachers.

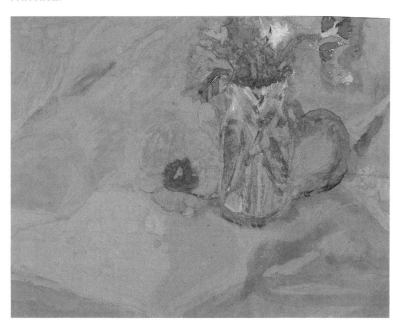

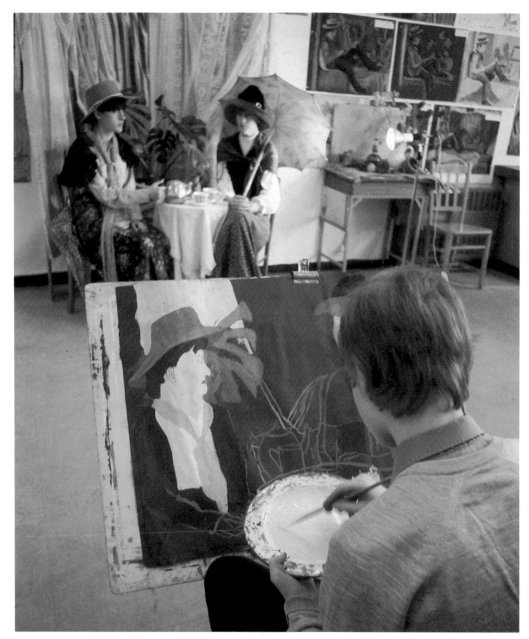

fresco meal. They are holding parasols in soft pink which warms the light that falls on their features, and they are wearing long floral and lace dresses. The china on the table is decorated in blues and greys. The colour, the lighting and the subject are designed to make the fifth formers want to paint. Whilst there are obvious visual references to Monet and Renoir, pupils by this stage have acquired an independent seriousness of purpose which is reflected in the confident and craftsmanlike way in which they set up their working positions. Some choose to erect their easels on table tops to look down on the scene so that hats and table tops make an orderly pattern of

Left School 3, 5th year
These pupils select their own viewpoints, use an angled drawing board to support their papers and mix and test their paints on separate palettes.

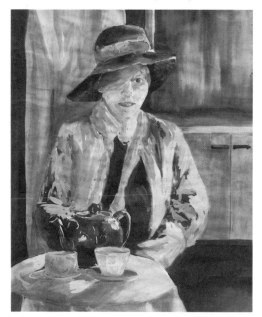

shapes. Other pupils prefer a lower eye level. They note that their view of many distant objects is interrupted by nearer ones so creating unexpected shapes within which they are able to discover what for them are new orders and visual entities different from verbal ones.

One of the teacher's skills lies in her anticipation of pupils' likely responses. She has chosen those subjects which she knows her pupils enjoy and which, at their level of skill and perception, they can paint. The heart of this teaching strategy is the head of

Below and left School 3, 5th year
Pupils respond in different ways to the same subject; for example a dramatic interpretation and a sensitive portrait.

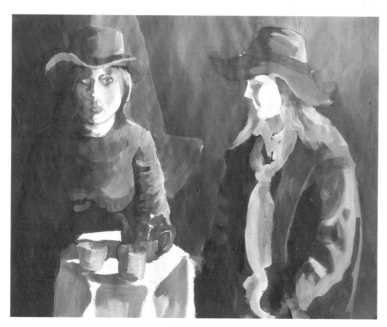

department's office in which an annotated photographic record of the work of the department, during the life of this school, is displayed on the walls or in ready-reference files. This record makes it possible for the staff to look back on their practice and improve it by distinguishing between those things which were merely fashionable and those of real worth which could be repeated and critically developed. Of the 50 candidates who submitted drawings and paintings for GCE O-level in 1981, all obtained a C grade or above, and of these 28 were awarded a Grade A.

In school 4 the teacher of embroidery and textiles prefers the objects and materials to be set out before the pupils come in. Because she likes to have unusual and sometimes expensive and ephemeral objects in variety,

she arranges drawing lessons for all the various age groups during the same week. Carefully arranged material, ranging from large tree branches to minute seeds, from dried and fresh flowers to whole and sliced vegetables, creates a certain drama as pupils enter the studio.

The abundance of source material is explained by the teacher. She believes that by the time pupils are in the fourth year, their ability to make a choice of subject matter is an important part of their artistic development. The drawings they do will be developed into embroideries or weavings, batik or screen prints and they must learn which individual pieces of source material will lend themselves more to one medium than another.

Observation and response
The second group of teaching skills are those concerned with the development of the pupils' skills of observation and response.

In school 2 one of the declared aims of the department is "to develop skill in observation and recording, to recognise subtleties, and to discriminate". Some aspects of how this is done are exemplified by a lesson with a class of second-year pupils. They are drawing from life, using as a model, a fellow pupil (who will get a separate lesson after school to make up for not participating in this one). She is sitting in a chair on an improvised rostrum. The class has been given large sheets of grey paper and are drawing with blue, brown or purple pastel. It is clearly a serious lesson in learning to look straight.

"Look first" says the teacher, "For every

look at your drawing, look twice at the model". "Test the directions you see against verticals and horizontals". "That is nicely drawn, very tender and beautiful. You can draw like that by looking hard".

The nature of drawing and seeing as a process, proceeding from conjecture and speculation to conviction and understanding is stressed;

"It doesn't matter if you get it wrong at first as long as it is right in the end" and "don't give up now; don't become flushed with success!"

As work continues, pupils become more ready to respond to the teacher's

School 2, 4th year
There are sufficient smaller plants and other objects for each pupil to have one and observe it closely.

encouragement (in the context of free-hand drawing) to dispense with inappropriate aids to confidence such as rulers.

Underlying this approach, with its stress on developing competence in observation and recording, lies a belief in individuality and the role of art in the curriculum as a vehicle for the expression of feelings as well as ideas. Pupils are taught skills as the means of achieving these ends, skills not only of seeing and handling tools and materials, but skills of discourse, finding words to discriminate, characterise and to judge.

It is customary for pupils to present homework drawing books to the teacher at the beginning of the lesson. At a later stage they gather round to discuss their work and to hear her comments. The teacher holds up a particularly well observed drawing of a

kitchen interior made by a girl in the class. "She could not have invented the way that coat hangs on the chair", she says, "she had to *see* that". It is true that the singular arrangement has the surprising quality of observed forms and is unlikely to have been the product of imagination. It is equally true that the pupil could not have seen the form of the coat had she not been taught to look in a disciplined way. More particularly as she had learnt to look she had learnt to trust her perceptions and to record them.

The atmosphere in the art room of the head of department is relaxed yet purposeful. Giving out and clearing up

School 2, 4th year
Two grades of pencil have been used in these drawings of an artichoke.

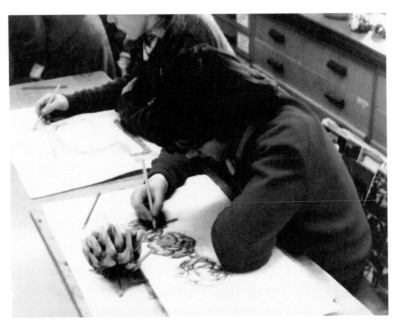

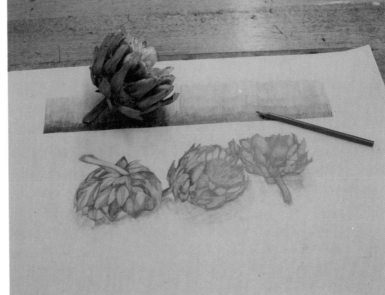

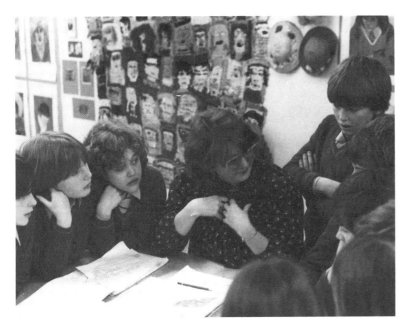

Left School 2, 1st year
Homework drawing books are marked in class
and the teacher and pupils discuss the work.

Below left School 3, 5th year
Preparation sheet for 6 hour GCE O-level art
paper

Below School 2, 2nd year
An embroidery, 4″ x 4″, based on a drawing done
for homework.

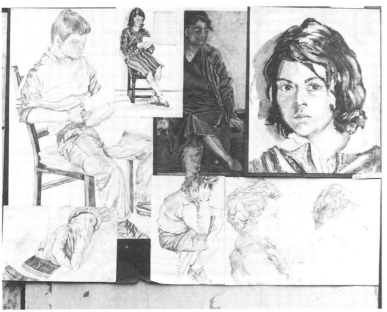

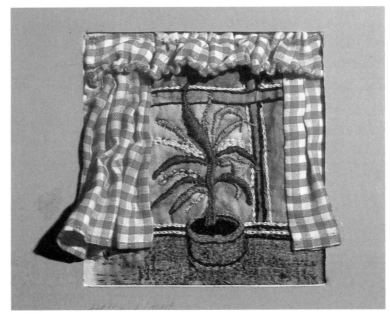

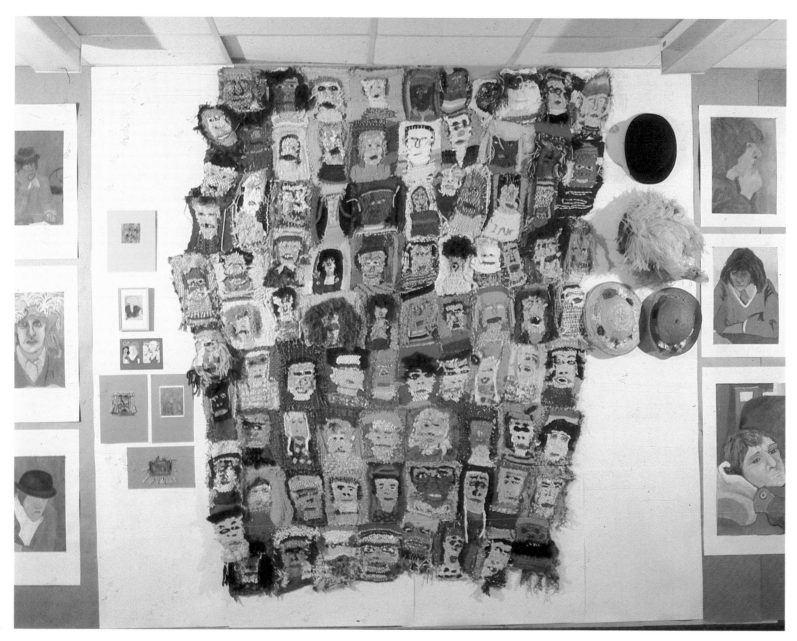

materials is done without fuss. Whatever needs to be organised, carefully arranged groups of objects, materials, paper, is ready before the class enters. Pupils are known by their first names and receive much personal teaching. The complexities of visual representation are made more manageable by concentrating on a few issues at a time: colour is at first limited to "families" of colour; drawing is concentrated on directions, or relationships of scale; and straightforward advice is given about handling paint, or using pencils and pens effectively.

The department has a policy for assessment, referred to in Chapter 6, which has been carefully related to the aims, objectives and content in its scheme of work.

In the corner of the open-plan art suite of school 5, a very large still life group has been set up in order to provide material for a 16 hour drawing to be carried out over 6-8 weeks.

● Seven fifth year pupils are sitting round the group, while eight others are completing unfinished work from their folios at side benches. Because the group is available over an extended period, pupils may work from it

at times when they decide that their energy and concentration are at their best. The theme is mechanical and sombre: two motorcyclist's helmets and a black riding suit; spanners and tool box, plastic bottles and a blue anorak on a blue and grey blanket.

There is much talk before and during the lesson to explain the choice of objects, their juxtaposition, and their qualities – eg shiny plastic next to a woollen blanket. They have been carefully chosen for their interest value but are also equally carefully arranged to enable pupils to grapple with linear, tonal and colour analyses. The drawings, on A1 size cartridge paper, are to be carried out over 6-8 weeks both in timetabled and personal study time. Pupils are to keep a log on the back of the drawings of the elapsed time and the still life group will be retained

as long as necessary. The instructions are very clear: the colour, thinned with much water, is to be broadly applied with a one inch brush in order to place the masses in the right position and get the feel of the group as a whole. Other media, eg coloured crayons, oil pastels, and conte crayon will be used to build up a drawing over this first broad statement when the pupil is satisfied about composition, proportion and accuracy.

These skills in the use of paint and the teaching of colour sense are also given special attention in school 6.

Several years ago when the head of department was given the opportunity for secondment, he took an MA in painting, working for 12 months in the art studios of a polytechnic. His feeling for art and the visual problems he describes when tackling

Left School 2, 1st year
An assembly of woven portraits (made on simple cardlooms 10" x 8") made directly from observation, using coloured wools and other fibres.

Right School 2, 2nd year
A pen and ink drawing; emphasising pattern and texture, of an antique doll.

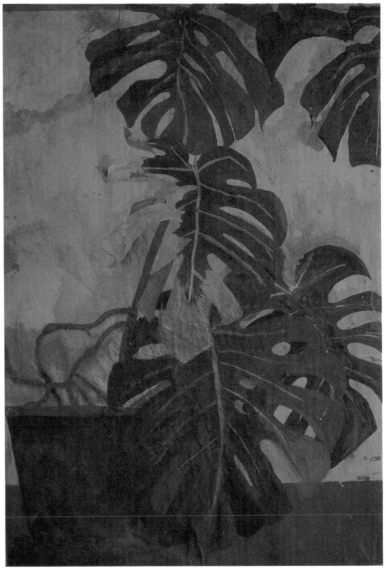

School 5, 5th year
16 hour drawings using several graphic media. The still-life group is available over a whole term to enable pupils to work on these detailed studies at their own pace.

School 6, 4th year
This painting, based on direct observation, reflects the teaching of colour relationships and qualities of paint in this school.

his own work are part of the impact he makes upon, and the authority he has with the pupils. In conversation, he revealed his sensibility in dealing with their artistic growth. His view is that –

"These children have manual dexterity, which is readily translatable into drawings. Drawing is the best start because you can talk about the skills and teach them. Colour is more difficult; you can't really define blueness or redness, in the way that you can define the function of lines on a paper; one needs to develop feelings for blueness or redness over a period of time".

"When a child makes a start on a painting and selects a colour he then has a problem of selecting the next colour. We try to educate them in the selection and use of colour by giving experience of colour and talking about it. Like the use of local colour from observation, or the varying impact of a particular colour according to what is placed next to it. We encourage improvisation in colour; once colour is related to paint and painting and it's on the surface of the paper, it can be discussed.

"In my own work, if something is happening to the painting which I am enjoying and I'm being carried away by it, I try to understand what is happening and talk about it to the children".

The range of colours is always restricted in order that the pupils should learn the skills of mixing and judgment. Both teachers give demonstrations and explanations of colour mixing; they talk about families of colours, their function and effects. Pupils are encouraged to make tests on scraps of paper and hold the test strip in the potential position on the painting – remembering that much time is spent on each painting. They teach the pupils that painting is not just a matter of filling in spaces. Each pupil has a large mixing palette, stiff hogs hair and soft nylon brushes.

"Hog hair gives a tactile quality – they can feel the paint leaving the brush". "The painting is an organic thing which is altering, changing, growing. I encourage them to paint over things, and to learn to enjoy their intuition. If it feels right on the paper, if they are beginning to feel pleasure from using coloured paint, they are in a state to learn control and recognise the need for control."

Outcomes

The teachers in these schools emphasise first-hand experience and demonstrate its value to the pupils in terms of perceptions and skills. Its value is evinced by pupils in the following ways:

● Pupils are provided with an opportunity to share their views and perceptions of the same experience. They learn that they may each have different perceptions of the same object and different responses to the same experience

● Common subject matter provides a tangible basis for criticism of each other's work

● Their own observed world, depicted in their sketch books and paintings, provides a means for developing individual values and

School 6, 5th year
This painting is based on a combination of direct observation and photographic reference material. The photographs were taken by the pupil in the Forest of Dean

distinguishing them from fashionable or
received ones

● Their drawings of their own environment
are an acknowledgement of the relevance of
where they live

● By working from direct observation,
pupils build a repertoire of experiences
which they may draw upon later

● The pupils learn that to make a particular
kind of mark stand for something requires
that other marks must follow and relate
logically to it

● The aptness of the metaphors which
pupils make is encouraged by the use of first-
hand sources

● Working from first-hand experience
provides the opportunity to test the language
in use against feeling or sensation

● Working from first-hand experience also
provides opportunities for the translation of
what is observed into form, tone, line,
texture and other kinds of analysis; for the
discovery of patterns; for colour matching.
The ways in which carefully structured
lessons in "seeing" and recording through
drawing lead into design and craft are
described in Chapter 5.

School 6, 5th year

18 A painting from direct observation of a lichen.

Chapter 3 An analytical and critical approach

There is a long tradition of learning and scholarship at school 7 and the work of the art department reflects this.

While much of the ethos of the art department can be attributed to the professional vitality of its leader, team teaching is customary and the youngest member of the team comments "No one keeps secrets, all our teaching is discussed openly. We rely upon each other to watch its effect upon pupils and there are no hang-ups because we speak our minds straight away."

The main aims of the department are enumerated with clarity and deceptive simplicity
- that all should be able to set down what they see or imagine as adequately as they would communicate the same with words; to have that skill that would serve "seeing" and make translation possible
- that they could "read" a master work with that insight and understanding that it would be necessary to have to read a novel
- that they should "read" a landscape and understand how it might be ordered; to be sensitive to the needs of the environment
- that all learn to manage abstract concepts; to select, order and, above all, to coordinate relationships.

The usual pattern appears to be that of an introductory lesson followed by a lengthy period of investigative drawing, leading to a brief craft project clearly associated with the drawing. Persistence and application are encouraged, and in some cases demanded. There is a code of studio discipline.

- On the ground floor of the department, which is open in plan and well lit, four large brick pillars support a gallery above, mainly used by the sixth form. Two other rooms lead off the main studio; one is a general workroom but, for this first lesson most of the second year boys are gathered in a library/lecture room lined with books. At the front is a table covered with clay constructions and behind the teacher there is a series of drawings of churches. The lesson begins with a reference to the drawings that

FREE DAY	1 9·05-9·45	2 9·50-10·30	3 10·30-11·15	4 11·35-12·15	5 12·20-1·00	AFTERNOON 2·00-4·00	6 5·10-5·55	7 6·00-6·45
Mon			Lecture D1	1st Yr A d4, Remove B, Remove G	1st Yr A d4, Remove B, Remove G	1st Yr A d1·ds·Ms, O Level Group 1	MS 1st Yr 1·2, MS 2nd Yr	7·15-9·15 1st Yr A MS Group 1
Tues	1st Yr A d4	Lecture D4, Remove C, Remove F	Remove C, Remove F			2nd Yr A, O Level 3 dim.	O Level, O Level 3D	O Level, O Level 3D
Wed (9·05-9·45, 9·50-10·30, 10·50-11·30, 11·35-12·15)	1st Yr ds, Remove D	1st Yr ds, Remove D	Shell C, Shell D	Shell C, Shell D		Art Sch. Works Group, Pottery Works Group, Theatre Works Group	MS 2nd Yr, MS 1st Yr 1·2	7·15-9·15 2nd Yr A
Thur	Remove H	Remove H	1st Yr ds, Shell E	1st Yr ds, Shell E		2nd Yr A, O Level Print Group 2	O Level, O Level Pt·3	O Level, O Level Pt·3
Fri	1st Yr A d4, Remove A	1st Yr A d4, Remove A	Lecture D1 s	Shell A, Shell B	Lecture D2, Shell A, Shell B	1st Yr A ds·MS	Shell Q	Shell Q
Sat	Shell P, Remove E	Shell P, Remove E	1st Yr ds			Art Sch. open to all, Pottery Open to all	Art Sch Pottery	Open to all, Open to all
Sun				Junior Art Society		Art Sch. Open to all, Pottery Open to all		

The art department timetable includes pupils' free time and weekend opportunities.

were done during the previous term. These drawings are part of a year long theme called 'Viewpoint'. The theme is redefined and the 20 or so boys in the class are questioned about its aims and objectives. The drawings are discussed in detail and particularly the elements of perspective, and how things are made to look solid by establishing an eye level and deciding on the directions that lines take to it and from it. The teacher reminds them how these drawings evolved and how other boys developed their ideas three-dimensionally in clay. Two sorts of approaches are identified, the figurative and the abstract. Two key words, 'realistic' and 'abstract' are then examined in relation to the character of the church which they had drawn. Notions of 'wrongness' and 'rightness' are raised; how a given drawing has changed from being right to being wrong or vice versa. The reasons for choosing a particular medium are discussed.

In another studio, two teachers hold a discussion with a group of 13 year old boys on the subject of 'character'. The room itself has a 'character' acquired from the presence of both old and new books about art which give a sense that the present discussion is not in any way unique. Pupils offer several interpretations of the word 'character' all of which are taken seriously and considered. They include references to characters in novels, plays and members of families. Then examples are used to make pupils aware of the way visual aspects of form and colour affect our awareness of character and characteristics. The character of surfaces, especially those evident in the room, are observed and their qualities noted. Pupils are questioned about ways in which surfaces might be recorded. Some remember that they have made rubbings in the past. For those who are unfamiliar with the process, the teacher demonstrates it and prepares paper and large crayons for all. Pupils are then told to use a building in the school to record textured surfaces, which they do, and upon their return are surprised at the quantity of material they produced and its variety. They are being given an opportunity to identify and talk about textures and visual characteristics.

School 7, 15 year olds
Relief sculptures in clay are one part of a series on the theme of Gateways.

School 7, 14 year olds
Studies in a "pointilliste" style

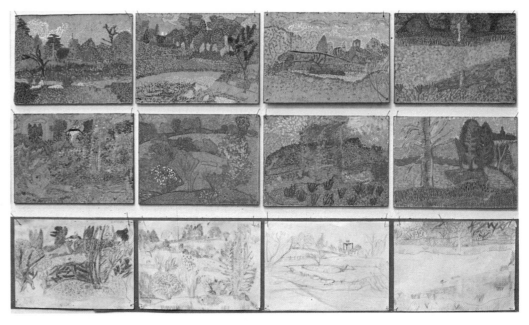

In order to reinforce these concepts and at the same time see their work in the context of the world of fine art, the boys are then shown studies of a Vermeer painting and a photograph of the site on which his painting was based. They are encouraged to note that Vermeer has abstracted qualities from the landscape to record particular characteristics. There follows a discussion about the abstracting nature of photography itself. Then, the characteristics of two paintings by Braque are compared with those of Chagall. Paintings by the latter are described by the teacher as a pictorial essay about events in a person's life. Paintings such as these, says the teacher, demand to be interpreted in a particular way, they have to be read. The choice and character of events in art is to form the basis of next week's compositions in collage.

One strength of this approach lies in the reinforcement given to their critical and historical studies by the pupils' own attempts to solve artistic problems. This process also works in reverse – the careful discussion of how an artist has tackled a pictorial or sculptural problem can enhance the pupils' own artistic skills.

Teachers are encouraged to declare their own positions about art and to be forthright about stating these positions in debate and most of all to urge pupils to acquire individual points of view. Historical approaches to common visual problems, such as perspective, are favoured: Renaissance paintings are studied not only for their symbolism but also for an understanding of perspective techniques. The relationship between technique and the development of symbolism is then brought up to date by provocative and informed discussions about more recent work. This 'constant talk about art' has helped to build strong bridges between the verbal and the visual and between pupils and teachers.

In this school a great deal of time (up to a term including free time) is invested in each piece of work backed by investigative and

School 7, 16 year olds
Pupils are encouraged to acquire individual and informed points of view. Book illustrations, slides, prints, originals and visits to galleries are all used to foster talk about art.

School 7, 14 year olds
The shapes and decoration of thumb-pots are influenced by natural forms.

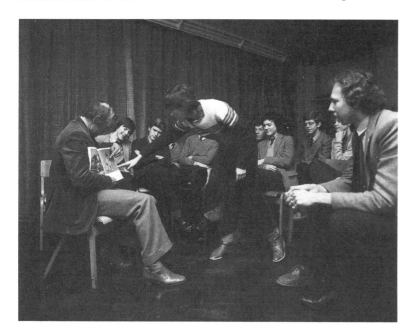

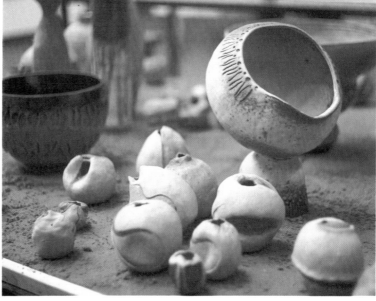

Below School 7, 16 year olds
Drawings and wire sculptures depicting human movement.

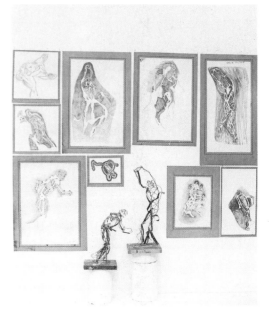

observational studies. Although pupils do not have individual folders until they are committed to O-levels there is ample evidence of the amount of research that is done for each single piece of work.

In order to record a sequence of events, pupils are encouraged to photocopy their drawings at different stages and build up a life history of each piece of work that can later be examined and reflected upon. This strategy enables teachers and pupils to discuss alternatives at different stages and photocopies can be worked upon rather than the actual drawing. Alternatives can be followed in different directions using other photocopies and comparisons then made. The sets of drawings and possibilities explored clearly illustrate, for the pupils and teachers (and for parents), the exact path that work has followed and the choices which have been made. Some have obviously been more successful than others but, as they are to have opportunities to develop ideas in both printing and pottery this year, they will have other chances to succeed.

Twin slide projectors are permanently available to help pupils compare the structures of drawings and paintings, to help them to identify the conventions used and to understand the need for consistency in the way the subject matter is perceived and interpreted. Paintings of similar objects by different artists are compared and their characteristics noted. The method of assembling a drawing is compared with that of a building, a poem or a sentence. The head of department often says to pupils: "You have to realise whenever you notice something, that you are seeing that shape, in that way and at that moment for the first and last time." He believes that the concept of talent is not always a helpful one in art education because it obscures the fact that those who are prepared to work at acquiring an understanding of visual experience and of the language which makes it possible, can achieve greater artistic development than those pupils who have only the technical skill of representation. He explains the increasing numbers who wish to take up art by saying "they realise that they can all become visually literate. They can see that my colleagues and I succeed in teaching a language which they can learn. The emotional responses which are evoked by observed and felt phenomena lead to knowledge only when they are disciplined and structured by formal expression".

The department's achievement is evident in pupils' work. Monochrome studies show depth of feeling and a quality of technique which are rare in adolescents. Colour is developed, as a natural extension of drawing, into analytical and lyrical prints and paintings. The constant challenge to evaluate their own work leads to the development of verbal skill in analysis and criticism.

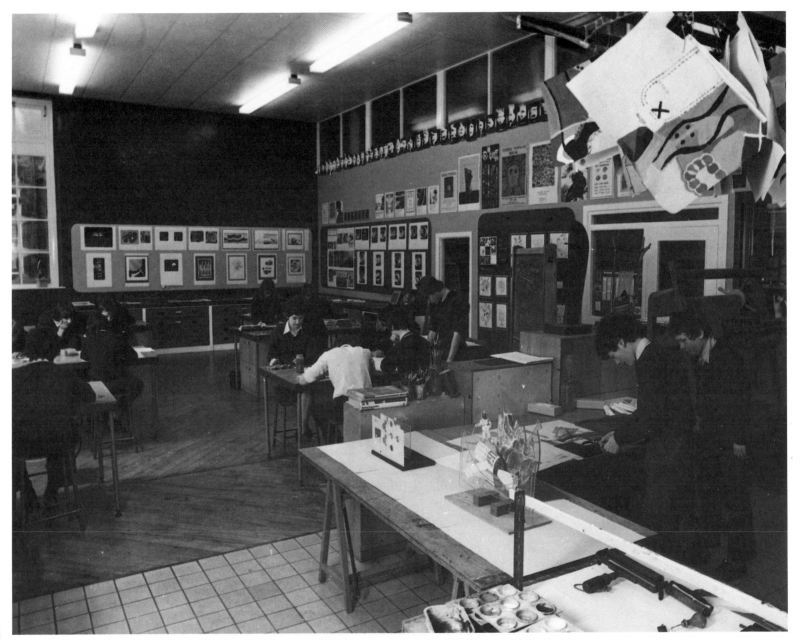

Chapter 4 A small department

School 8 is a small secondary modern school situated at the edge of what used to be a densely populated area. It is built, like the surrounding houses and factories, of gritstone darkened by industry. Its entrance is approached by way of a narrow yard, the walls of which are formed by the sheer sides of neighbouring buildings. A short flight of steps and a small door give entry to the school, where the contrast is dramatic. The interior atmosphere of space and light has been achieved by decorating in muted yellows a former corridor refurbished as a welcoming foyer. At eye level examples of pupils' work are presented on lightweight screens, and each piece of work is mounted and placed so that it may be properly seen. The subject matter is drawn from daily life and this particular set of work, by the juxtaposition of words with visual images, draws attention to such issues as industrial safety, care for human and animal life and the conservation of energy and resources. A range of newspapers lies alongside and, since the headmaster's room is adjacent to the foyer, he is often engaged in discussing with pupils their views about items of news and the pictures on display.

The interior of the art room can be seen from this foyer through a double-sided display unit which provides a visual link between the making of images and their public use. The art studio has been adapted from the old school hall and is filled with light from high windows. There is a considerable amount of wall space used to display pupils' prints, drawings and paintings and there are high window-sills for the display of three-dimensional work at eye level. The heaviest single piece of equipment is a printing press adapted from a mangle and used for etching and intaglio printing. Otherwise all furniture is relatively lightweight. Wooden storage cupboards, which are easily moved are made up as room dividers. Drawing stools, of the kind known as donkeys, when not in use for drawing are stacked to mark out an area for storing lighting equipment. Two of them placed together support a large storyboard for film-making. Furnished in this way the single room is readily adapted to a variety of functions.

School 8, 4th year
The art department has constructed its own printing press from a mangle with rubber rollers and mild steel angle.

Left School 8
The art room is a former assembly hall

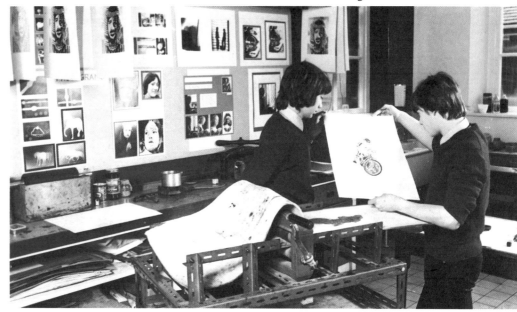

There is only one art teacher, and although he is a practising printmaker, he teaches drawing, painting, pottery, sculpture, printmaking and photography all to a high standard. The graphic images pupils make and the use of film and photography in the school are exceptional. He imparts the craftsman's standards of order and respect for tools and materials, but adds to them the expressive aspects of the subject and the aesthetic qualities of the process, as in the relationships sought between types of printing ink and paper. The ethos which he has established is that of a versatile and knowledgeable artist/craftsman skilled in visual communication. The expectation that pupils should take care and think responsibly about what they are doing is clear to them and is constantly reinforced by his words and actions which remove the need for written rules. This expectation of workmanlike co-operation extends to the good-humoured teaching style.

"For printing you really need two people, one with dirty hands and one with clean hands, but one person with two hands will do". When seeking a particular quality of response either in an approach to a technical problem or a matter of judgement, the teacher is able to draw upon his knowledge of the pupil's experience to supply appropriate metaphors. Thus printing ink is adequately rolled when it "makes a thin hissing noise and looks like velvet under the roller". Ideas are expressed in practical terms so that a pupil drawing from life but paying too little attention to the model is told that "That is where the information is. I should like to see your head moving more".

Practical intelligence is respected and reinforced: a boy attempting to wash printing equipment at a sink is reminded that oil and water do not mix; a pupil asking for white paint is invited to look for it herself but first to think where it is likely to be. In these small matters the teacher's expectation that pupils should learn from experience is evident.

School 8, 4th year
Photographs and drawn or painted images are often used together.

Early habits of application are established in the first and second year by an introduction to drawing and designing. Attention is given to drawing from observation and the development of images, while using the different media with which the pupils have become familiar. Second year portrait paintings sit alongside portraits using cut paper and rhythmical line drawings. At this stage photographs and drawn images are used together, for example where features from magazine pictures are linked by drawings and further developed into card prints. An unusual feature of the course is the linking of graphic and photographic images by the careful relating of qualities of tone and line.

The way the art teacher organises the parts of a lesson shows his understanding of the way his pupils learn: for example a figure drawing lesson is set up by arranging pupils in awkward injured-looking poses amongst a pile of furniture and drawing boards, under the theme of "After the earthquake". Because of the disarray, with figures lying at unconventional angles, the pupils cannot bring preconceptions to bear. Those with sophisticated schema for drawing conventional figures have no advantage over the rest; they all start at the same point; they all have to look and keep looking. During the lesson his instructions are given in such a way that pupils can isolate the skills and then see them in context. For example, after an initial discussion of the earthquake scene, the teacher moves amongst them giving individual instructions loudly enough for them all to follow, "if the cap fits".

"Don't use that bone in your wrist like the pivot of a pair of compasses, move your hand from the elbow and the shoulder (demonstrating). "Make full use of the models while they are posing. I'd like to see your head moving more. Look and look and look, when your head stays down you are plucking it out of your memory, which is a pointless exercise when you have the models in front of you."
Apart from displaying the pupils' work,

School 8, 5th year
A simple but effective montage of photographs and drawing.

School 8, 4th year
Relief prints using card, paper, string and glue.

the wall surfaces are used to demonstrate the importance of image making in the world outside school. Illustrations of industrial equipment and other features of the industrial landscape, ceramics, illuminated manuscripts, brochures on art colleges, a 1920's art deco advertisement for Alfa Romeo, photographs illustrating poems, all feature alongside pupils' own graphic and photographic work. A talk on the Bugatti family is given, apparently spontaneously, using such collected material to show how furniture, sculpture and automobiles are related not only in matters of design and engineering but also in human, and in this case family terms.

The highest levels of work and certainly the most sophisticated, are in photography and aquatint etching. The studio has a small

Right
School 8, 5th year
Photo-montage

Below
School 8, 4th year
Editing 8 mm film.
Photography and film making are part of the art CSE course.

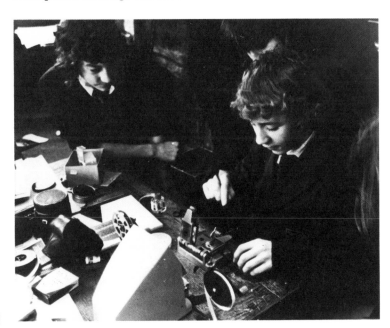

darkroom attached. In spite of its considerable age equipment has been carefully used and maintained, and photography and film-making are a featured part of the CSE fourth and fifth year art courses. Emphasis is placed on using photography to communicate information or feelings. Results are often combinations of photography and graphics or photography and lettering, as in the case of illustrated poems. No attempt is made to teach the theory or the history of photography, the technical matters dealt with are confined to those basics required to enable each pupil to produce a straightforward piece of work. The photographic work is refreshingly unpretentious and effective, being seen not as an end in itself but as a means of providing new starting points for development in other media, or extending existing visual ideas which exploit the locality of the school.

It is in the fifth year that the value of the teacher's expectation of responsible craftsmanship is manifest. Pupils are able to work on such varied activities as film-making, darkroom processing, block printing, engraving, drawing and painting, independently confident that they know how they are expected to use the studio. The teacher is free at this stage to attend to matters of refinement and judgement.

In 1981 47 per cent of the fifth form took art in CSE. Of those pupils 95 per cent were awarded grade three or above and 57 per cent were awarded grade one. Pupils do well in local art competitions and many are known to pursue their interest through local art and photographic societies. Each year some pupils enter further education art training by means of vocational courses or foundation courses and have gained a variety of posts in photography, graphic design or related work. For example, one former pupil, a graduate in fine art, recently visited the school as part of her postgraduate study and has obtained a permanent teaching post and another has graduated in architecture.

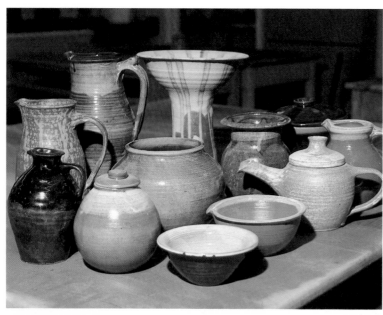

Left School 9
Thrown ware by 4th and 5th year pupils.

Below left School 9, 5th year

Below School 9
Pupils build outdoor kilns and fire them as part of
the ceramics course.

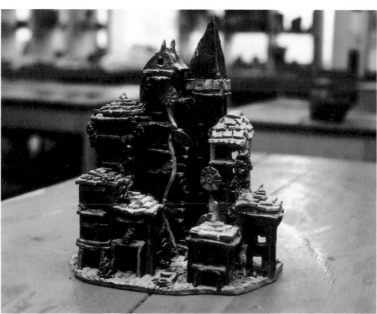

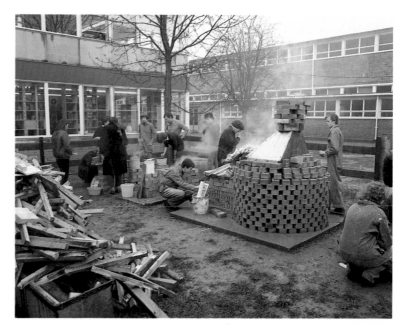

Chapter 5 Craftsmanship and design in art education

Craftsmanship and design are essential constituents of art education. This chapter looks at six schools which have, in their own individual ways, been successful in developing craftsmanlike skills and attitudes in their pupils. The first of these, school 9, is a comprehensive school in an attractive part of the south-west with a large art department, one studio of which is modestly equipped for pottery. Full use has been made of what is available and by means of much improvisation it has been turned into a workable and efficient studio.

The teaching is based on the belief that pupils gain satisfaction from making things well. The work is of two distinct types. Formal thrown ware is made in the studio pottery tradition where the disciplines of function and form are paramount. Other work of a more personal, even whimsical nature allows pupils to discover the disciplines which ceramic materials impose on their ideas.

The output of the pottery is very large. Four tons of clay each year is barely sufficient, even though it is used carefully and frugally without waste, used clay and parings being carefully reclaimed. Every week there are six firings, the teacher attending to the needs of the studio whenever necessary. The pottery attracts pupils of all abilities and ages. For example, one pupil, who is not academically strong, has made slowly and painstakingly some large, intricate and fantastic images out of clay.

"I started making these constructions about a year ago, and they gradually progressed. I first made tube shapes and then found that if I put windows in them I could make a sort of village. "This", pointing to his latest construction, "is the biggest so far" (it is about a metre tall) "and is a sort of fairyland. It's about the sixth I have made and each is better than the last and new ideas develop from it for the next."

The quality of power of his tower structures come from the sensitive relationship of their component parts. They are well-made and combine his skill in the use of clay with his knowledge of architecture. The mood of some is sombre, of others delicate. This pupil located a source of clay in a field near his home and brought some of it to school. He cleaned and test fired samples and now uses it to produce pottery in a studio improvised from a shed at home.

Others in his group are trimming up some slip-cast bottles they have made, using existing moulds, in the school's own mix of porcelain. Although the technical finish is generally good, some minor flaws cause the pupils to decide that what they have done does not match their own exacting standards and they are rejected. Their critical abilities spring in part from constant practice in achieving high standards so that they are willing to reject what is less than good; in part from the department's established tradition of excellence; in part from the standards set by the teacher in his own work; in part from his skill in helping pupils to learn to scrutinise their own work with care and understanding.

"They mustn't just think of me as a teacher. They must see that I value the activity as well. I always keep some work on the go and we talk about what I am doing."

"I had to provide proper facilities for practice. If the older pupils want to throw properly they must get to the wheel about 20 times a week. It takes a certain amount of bullying to get them to do it."

The teaching is precisely planned: aims are deliberately limited and techniques are clearly described and demonstrated within a coherent programme. At first pupils are not encouraged to design on paper as young pupils are unable to relate drawing to their work in clay. They might draw in water on a table but mainly talk is used to define what is needed. Design develops in the making. In the fourth year pupils build up enthusiasm by concentrating on making pottery. The history of ceramics starts in the fifth year as part of the scheme of work leading to a GCE

pottery examination. In contrast the sixth form work out many of their ideas as drawings and can readily handle the transposition between two and three dimensions.

Beyond the immediate task set, a freedom exists for the individual to develop a personal idea, and the clear framework set by the teacher demands the development of skills and provides security for creative endeavour. The pottery teacher and the rest of the department benefit from a head of department who believes in the value of his whole team thinking and discussing together.

Although craft skills are also important in school 4, a special emphasis is placed on designing. The pupils' designs are based on direct observation and analysis. Although the school is a new one and has many good facilities, the unrelieved concrete, the leaking roofs and the stained walls produce a visually drab and depressing environment. Despite the lack of external views and poor natural light, two of the art staff have created an attractive atmosphere inside part of the art department. In the textile area work, tools and equipment are carefully arranged and reflect a disciplined approach to organisation. The main method used by the teachers here is to develop careful looking by means of drawing and to use drawing as a basis for designing in textiles. The displays are a key to their approach. A description of two classes illustrates this process:

● The first, a group of 20 second-year pupils, enters the textile area to find a display already arranged on black paper on a side bench. The display contains minute seeds, feathers, leaves and carefully cut slices of fruit, all put in transparent envelopes for preservation and ease of handling, together with plants, vegetables such as leeks, peppers and a string of garlic, flowers and gnarled and knotted branches. There is some emphasis in this lesson on colour, and oil pastels and coloured pencil crayons have been set out. There are aids to careful observation as well in the form of two kinds of magnifying lenses.

The lesson begins with the teacher talking about what they are going to do and why she arranged this display. She asks questions about colour, the soft blue of the iris, the several tints and hues of yellow in the daffodils, the chalky olive green of the eucalyptus. She aims to cause pupils to pay close attention and the vocabulary she uses helps them to become aware of subtleties — not any blue but azure blue. They talk about where else they have seen colours like these and find appropriate words to discuss the colours in the oil pastel box. They are reminded of the importance of mixing to obtain just the colour they observe. For this purpose she has made 'rubbing sticks' from pieces of grey felt, rolled up tightly and secured with masking tape. The children choose their paper from a

School 4
A wide range of natural forms are displayed for pupils to study and select.

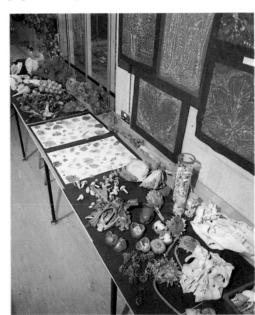

School 4, 4th year
A design in pencil for printing on fabric.

small range of sugar papers in muted colours, and consider the overall shape of the object they have chosen and the distribution of the major parts of that shape – before drawing it lightly on the paper; composition and placement having been taught consistently by all staff of the department since the pupils entered the school; it is important that they get the overall structure right, before attempting fine detail.

As they make their first marks the teacher talks to the whole group, moving amongst them and looking at their work. She asks them to find ways of describing their objects in terms of drawing; for example, to look at the different kinds of lines, the direction of the fibres and to pick out what they think are its essential lines. She reminds them that

School 4, 5th year

from these drawings they are going to develop some designs for batik, which will be further developed on tissue paper with inks so they need therefore to produce a good statement in their initial drawings with plenty of information. As the drawing progresses, the children work with a quiet intensity and while they work the teacher moves about talking to individuals, but loudly enough to be overheard. She looks at the daffodil with a child and shares her sharper vision. She sees the frill at the end of the trumpet shape and how the fibrous texture of the flower radiates from the papery pale brown spathe that encloses the flower base. A pupil's inaccuracies are turned to good use when others overhear advice on corrections.

The concentration increases as the double lesson continues. The teacher increasingly talks to individuals, less publicly now, about the use of shape, line, texture and colour to characterise the object.

The second class which follows, is a fourth year group of widely mixed ability and is taught by this teacher and her colleague who specialises in printed textiles.

● Some pupils are drawing and some working on screen prints, batik or machine embroidery. One teacher is assisting those

Centre and right School 4, 4th year
A preliminary drawing and subsequent embroidery. The use of fabric and thread gave a pupil with only moderate drawing ability opportunity for a sensitive interpretation.

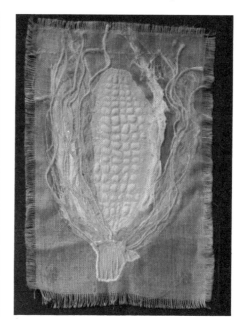

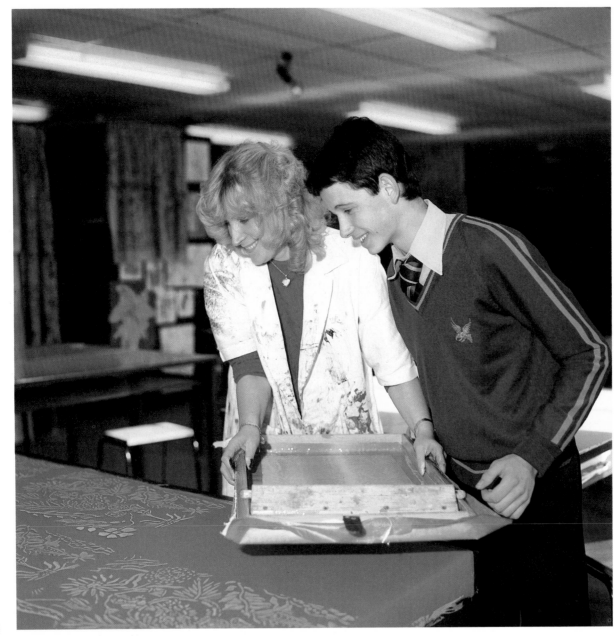

around the print table, whilst the other moves about the class. The open-plan accommodation aids this cooperative teaching. One girl whose sequence of activity typifies the approach of these two teachers, is beginning to translate her sensitive drawing of a corn cob into a fabric picture. She has observed that the leaves are browning, frayed and brittle, and reveal the ordered pattern of creamy yellow seeds. The teacher and the girl go to the area where fabrics and threads are kept. Cones of wool, cops of silk and hanks and bobbins of various threads have been arranged to look both inviting and to aid selection of colour and textural quality. Discussion at this point is crucial and centres on the qualities and colours of the object and how these might be interpreted in fabric and thread. The pupil chooses the materials herself and having stretched a piece of scrim, sets to work with a swing needle sewing machine. She has used a similar machine before but as the need for a new technique arises it is explained by the teacher. The design has not been pre-packaged as a way to teach skills but needed skills are learnt in order to help her to interpret the ideas which arise from her observation of an object.

In these textile studios pupils experiment confidently with ideas and skills. Their completed work reveals a sequence of steps from source material through to the making of a design. The earlier steps of absorbing experiences and recording them are used to generate ideas, which in translation into other materials are affected by the limitations and disciplines imposed by tools and techniques. Both the work and the teaching suggest that:

● Time is well-spent on looking at, touching and talking about well chosen objects
● The drawing of these objects both sharpens vision and helps pupils to understand the individual qualities they embody
● Drawings provide a good basis for pupils' own designs
● When designing in this way for batik and embroidery, a relationship should be sought between the individual qualities of the objects and the materials to be used
● Skills are better taught when needed for the work in progress, rather than in isolation

School 4, 5th year
A screen-printed furnishing fabric.

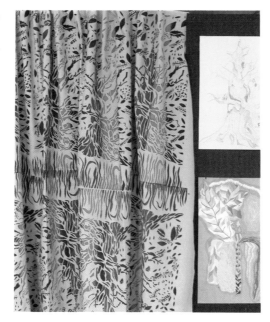

● A high level of craftsmanship should be encouraged in making, finishing and presentation
● Personal interpretation is important but to be convincing should come from careful analysis.

Another and quite different approach to textiles was seen in school 10, a boys' school with only one full-time art teacher. Here too drawing is the core of the whole course and the major activity in the early years. Upon this foundation, those who opt for art in the fourth year quickly develop further skills particularly in weaving of all kinds. Some boys work individually weaving, for example, lengths for cushion covers based on drawings and paintings, or rugs where they sometimes experiment using the same pattern in different colour ways. Others work cooperatively in groups designing and making very large and striking tapestries. The teacher's enthusiasm for his craft is obvious. He looks for "a positive involvement", not idle engagement nor even simple laudable occupation. The style and atmosphere of the art room attract numerous boys in their lunch break. They work in a room hung with old Kelims and Persian rugs, as well as their own work; visible evidence of a long-sustained tradition of weaving for both beauty and use. This living tradition is enriched by experiment: balls of wool are dyed, rewound and dyed again to provide subtle graduations of colour in a tapestry; rags are torn into strips and interspersed with wool and jute to increase textural interest; woven material is teased into soft sculpture and wool is felted and embroidered into nomadic caps.

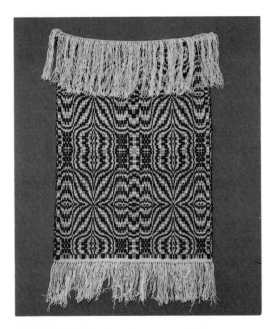

Left School 10, 4th year
A small knee rug; American overshot pattern in handspun wool.

Below left School 10, 3rd year groups
Large scale tapestry weaving is a highly developed craft in this boys' school.

Right School 11, 16 years of age
A panel painting 4' x 18".

Below School 10, 5th year
A tapestry wall hanging woven in wool on a cotton warp.

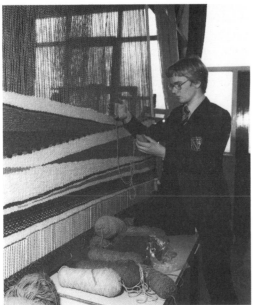

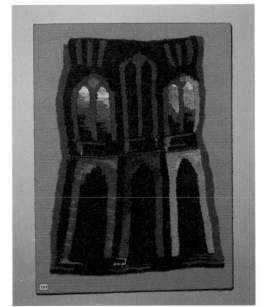

The impact of art on school 11 is very evident. The three main buildings all contain interesting displays of art work, which are regularly changed. The head of department's studio was intended, on the original plans, as a circulation space and pupils and teachers move through this art area when changing lessons. "I like other people to see the art department at work", he says; but in effect the whole space, room, passage and lobby is the art room, with displays of pictures, plants, a number of easels, drawing stands and tables. Paintings, some up to six feet in height, are part of the display of work in progress and confront all who pass through. A class of fifth formers is working; the atmosphere is busy, genial and good humoured and there is a constant flow of dialogue, easy and friendly, but serious. There is no doubt that this is a place for hard work.

The subject matter of their work is largely traditional: still lifes with plants, teapots, vegetables; portrait heads; studies from costume life; interiors with figures and landscapes. There are some stylised or abstract compositions but they are an exception. What is remarkable is the way in which the older pupils work in the service of the school and the community outside the school. The art department is inundated with requests for pupils to produce decorative panels, and there is an unusual degree of cooperation with the drama department in the design and production of sets and properties. Spaces for murals and panels have been negotiated in such places as banks and health centres. Senior pupils recently completed a series of panels depicting the development of a large national company for permanent display at its staff college near the school. The quality of this large scale work shows that the pupils have gained from the disciplines of real life projects. The limitations imposed by their clients concerning subject matter, size and colour scheme have been included in the design process, whilst leaving room for individual interpretation, style and technique. There is an air of reality and purpose about design in this department.

By contrast, school 12 is a large comprehensive school with a faculty of creative studies, including art and design, home economics and needlework, and CDT.

School 11, Mural by 3 pupils 16 years of age Pupils' work commissioned for sites outside the school.

The four teachers in the art department all work in one lofty studio; on entering one is able to look across a space crowded with objects of all descriptions and buzzing with activity. Each member of the department teaches in an area about eight metres by four metres and the divisions between these areas are made by low cupboards and shelf units, overflowing with artefacts, plants, materials and constructions. Most of the usual work of an art department takes place here but the work of two teachers is especially interesting. One provides a link between needlework and art, the other works in three-dimensions and encourages his pupils to make large-scale sculpture. His influence and the work it generates would be difficult to ignore; a life-size child on a swing, a model of an oil-rig the size of a wardrobe, and a giant portrait head four feet high. Much of it is marked by a robust and boisterous good humour; like the two tennis players, almost life-size, who enjoy a lively game on top of a store cupboard next to a forest of road signs constructed from old cardboard tubes.

A class of third-year pupils is divided into a number of small groups each of which has a different project:

● Some boys are busily constructing three skiers each about a metre high. One is bending thick plastic-coated wire into a rough shape and wrapping chicken wire around it, another is tying paper to his wire framework and the third is tearing pages from an old telephone directory, pasting them and applying them to his model. The teacher observes that the figures are too stiff.

He assumes various skiing positions for them to examine and they bend their half-finished sculptures to new poses. Other pupils are examining a steel, wire and concrete construction by a fifth form group which will shortly be moved to its permanent location outside. It is a bold statement technically and conceptually and makes these third-formers aware of the tasks and levels of expectation that await them if they choose to study art for the next two years. Not all the work done is illustrative: four girls have chosen a large bag of small plastic off-cuts, similar in form to an open pyramid, and are discussing ways in which they could be interlocked or joined to make an abstract unit construction.

Confidence is seen as one key to success: pupils work on simple group projects in their first year and during that time their attitudes to three dimensional work emerge. If they later prefer to move to other areas this is rarely questioned since interest is vital if success and enthusiasm are to be sustained. Preliminary drawing is not insisted upon; pupils develop ideas directly with materials. There are no hard and fast rules about time limits, size or subject matter. The unhurried approach to construction is that of a craftsman – even though he only has one pair of pliers – and he is always eager to support or suggest new directions or new ways of using materials. The sculptures are inventive and full of character and the head and other members

School 12, 3rd year
'The Bench': a sculpture in papier maché, card and wood.

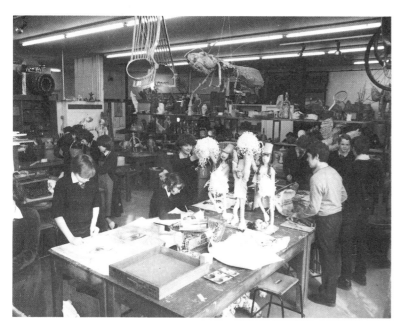

Left School 12, 3rd year
A variety of projects in progress in the sculpture area.

Below left School 12, 4th year
A painting of a local mill.

Below right School 12, 4th year
A landscape interpreted in quilting and machine embroidery.

of staff often visit both to enjoy the work and to secure another perspective on the achievements of pupils.

The second teacher allies the craft skills of dressmaking and embroidery to the artistic concerns of painting and sculpture. Here fabric is used as a constructional as well as a decorative material. She works in both art and home economics departments in a separate area which forms a link between them. An adjoining store houses equipment and materials much of which has been obtained as waste from industry or brought by pupils from home. Many highly individual machine embroideries and woven hangings are on display but the second year group of 20 pupils is working at present with fabric as a constructional material, on the theme of "A fantastic tent". It is a problem-

solving activity, which involves the design and making of a hollow three-dimensional form. After much discussion, pupils begin by producing sets of elaborate drawings as preliminary designs, and experimental paper models. Fabrics are then chosen and making begun.

● In this, the sixth week of their nine-week block of time in this area, the job is well-advanced. The constructions do not resemble conventional tents. One, made from triangular units of materials, unzips and folds up. Another might almost be a relation to a sedan chair, with rigid poles

Below and right School 12, 2nd year Systematic design work in the course of a project on tents.

made of padded fabric; a bathing tent is made rigid by quilting. A great deal of attention has been given to external finish, and stripes, piping and checked material are freely used. The sewing is very skilful and a great deal of ingenuity has been shown in solving the technological problems inherent in making hollow fabric forms.

A conflict exists between the need to fully exploit the educational value of the design stage of the work and the need for sufficient time to complete the constructions. The limitation of a nine-week block of time introduces too great a degree of urgency into the stages of work which precede the making-up stage. In this case there will be no time available for pupils to develop the better design ideas now emerging or

compare these in tests with their earlier prototypes.

In this work in fabric, experiences are systematically provided to produce designs and solve constructional problems of increasing complexity. The second year group had earlier designed and made solid forms based on a circus or fairground. They had all, through experience and study, identified the shapes, colours and movement of fair or circus. These experiences were then analysed to produce designs based on characteristics of forms and symbols rather than attempts to portray reality. The "tent" project then provided the first experience of designing hollow forms. A similar approach in embroidery and collage is illustrated by the designs produced by a third year group based on elements of local buildings. Careful

40

scrutiny and recording of parts of buildings, followed by library study, preceded the making of drawn designs.

The pupils, through the experience of operating as designers, coupled with discussion of their own work and that of practising designers, seem to develop a clearer understanding of design and a more informed, critical approach to the man-made elements in their environment.

One of the features of work in this faculty is the way in which the individual folders kept for each pupil retain, carefully mounted and presented, all the evidence of the development of their ideas as well as finished work. The faculty structure here is used to give pupils access to a wider range of materials and processes than usual; for example some embroidery incorporated mosaics made in enamelled steel. By the time pupils in this school reach the fifth year their work books, which contain drawings and their own writing, are of an advanced standard. They have learnt to design in three dimensions, to manage a variety of materials with skill and craftsmanship and to use them in a personal and inventive way.

The staff in school 5 (a 14-18 high school for girls in outer London) also stress this personal approach. The phrase "teaching individuals" cropped up many times in conversation.

"It was a surprise", said one of the staff, "when I first arrived at this school – quite different from my last school, where you had to crank up the lesson at the beginning. These girls come in, get their work out and start before you've even time

to catch your breath. In a sense they feel they are in charge. The open-plan layout of the department affects the way we work – there are no formal lessons. The work progresses continuously and there is continual monitoring. We only occasionally stop a class – for say, the economic teaching of a craft process".

The staff tend to work as tutors rather than class teachers, setting up an exercise and then teaching individuals as craft or artistic problems arise. It is, in many ways, like an art school in atmosphere.

The head of department has a special interest in ceramics and is an experienced teacher whose belief in drawing has

School 5, 4th year
Registering a screen-printed length of fabric.

provided a focus for art education in the school. One of his two colleagues is a print-maker who has developed his own business. Two and a half days teaching suits him very well and he is able to bring together in this way his twin commitments to art and to teaching. The other is a practising textile designer who sells her dress fabric designs in Germany, France, Italy, Japan and America. The fact that they are young and successful practitioners in highly competitive fields not only does much for their credibility in the eyes of more mature pupils but means that they are not likely to forget the exacting standards to which a designer must work. Craft practices here are professional in style, reflecting the expertise of the staff and at the same time matching the special interests of girls (many of whom come from ethnic

minority backgrounds). So that in this school it is possible to see dress-weight fabrics screen-printed in geometric and floral patterns, ceramic jewellery, large printed, embroidered and appliqué cushion covers and printed cotton lengths.

In the ceramics workshop a showcase of clay models includes small conversation pieces, such as a grandfather and grandchildren on a settee, a mother and child on a park round-about and a dustman at work. They reveal the department's tradition of working from subject matter which has been directly experienced and is chosen for its appropriateness to the medium. Work currently in hand continues this tradition but widens the subject matter to include ceramic jewellery and a whole variety of light-hearted translations of everyday objects – books, bread, ice-cream – into clay sculpture. Light hearted though the subject matter is, the teacher is concerned that pupils have studied the subject matter seriously so that they make their own, conscious, judgments about the form in which it should be expressed. Technique is taught when needed and helps them to become aware of the limitations of the medium and the constraints of the processes such as drying, firing and glazing.

The craftsmanlike approach is also seen very clearly in the fabric studio. Much equipment has had to be improvised and here they have been helped by the support of an active and enthusiastic technician. The teacher has adapted an ordinary but solid table for printing by covering it with a grey blanket, stapled on under the lip. Register is achieved by using white thread held down by masking tape.

The dyes are selected for their ease of use and are fixed by painting over with a solution, so that mistakes may be washed out before fixing. Girls know where materials are kept, prepare their own dyestuff, apply it with skill and work cooperatively in doing so. A variety of printing techniques like screen printing with stencils, block printing with lino and drawing with dye crayons, are clearly taught by teachers drawing on their own professional expertise and are therefore readily understood by their pupils.

Pupils are highly motivated and may, particularly in the fifth year, have their own

programme of work. To this end, the flexibility of the room arrangements allows an individual pupil, from time to time, to set up an individual work space where all her work, preparatory drawings, reference material, tracing, stencils and colour notes can be assembled with the prints in progress. Some gain greatly in confidence from having their collected studies around them but, in this school, whatever their talent, pupils take pride in well executed work.

Together these schools demonstrate a wide range of approaches to the teaching of designing and making. They illustrate something of the wide range of crafts which can be seen in art and design departments. Although practice varies widely there seem to be some common features. All the schools see it as important to have at hand a rich variety of natural and man-made objects of many kinds for study. The recording of this material, either by drawing or through direct interpretation in materials is the mainspring for much designing. The teachers are skilled in helping their pupils to engineer the translation of ideas or observations into a new material form, and are themselves good craftsmen in at least one field.

Left School 5, 5th year
Screen printed cushion covers. Some overworked with thread and appliqué.

Left School 4

Below School 7

Chapter 6 Organising the department

Ways in which some art departments organise teaching and resources to meet the needs of their pupils.

The pottery in school 9 is described in Chapter 5. The head of department sees his main responsibility as enabling his staff team to operate from their strengths. He encourages each member to develop his or her area of work imaginatively, but to relate it to his overall plan for the department as a whole.

Money is always a problem but self-help and improvisation are daily bread in this school. The pottery teacher said:

"I had to wait until I had been here about a year then I went round the school asking who was using each apparently redundant item of furniture. I then got all these racks and cupboards and actually managed to improve the department's storage."

Facilities for storage are always at a premium in art departments and especially so with sixth form numbers increasing. A large store has been planned by the art department by remodelling an area of corridor and like many other ventures in the school it will be executed by them with the advice of the Local Authority's architects' department. Similarly, kilns which were originally sited in the middle of the pottery studio have been moved to an adjacent redundant toilet by making an opening in the party wall.

An increasing demand for the subject in the fourth year has resulted in four art and four craft options being provided for 180

pupils from the year group of 270. There is a set time for departmental discussion for an hour at the end of one day each week. In addition, the head of department attends a meeting of staff in charge of subject areas each month. A recent topic for these meetings has been a curriculum review of the first three years in all subjects. This led the art department to enquire whether the staff in their separate disciplines, could identify a core of essential experiences. Each member of the department wrote a piece on what they thought to be fundamental, and the head of department focussed attention on areas of agreement and difference.

There are published aims for the whole department and broad curricular statements, into which the range of specialist activities are integrated. The art staff teach drawing, painting and sculpture, pottery and kiln building, jewellery, photography and print-making, and a detailed syllabus statement exists for each of these areas of study. For example, the pottery syllabus deals sequentially with a large repertoire of techniques and experiences. It states clearly that all children should have a working knowledge of the tools available and underlines how these should be cared for.

The art staff with the help of pupils have recently remodelled a hut which now serves as a photographic workshop and darkroom.

School 13 is also noticeable for the

strength and leadership of the head of department. It is situated in the north of England in the heart of a council estate of a new town grafted onto an old mining village. The school itself has suffered similar grafting problems in that new buildings have been added to old.

Streets, paths, corridors and staircases are often dirty and there is a great deal of litter both inside and outside. Although the department announces itself to visitors in the entrance hall its effect is generally cancelled out by much that surrounds it. However, by contrast, the staircase from the first floor to the floor of the art studios indicates that the art department cares for its own environment and about visual quality. Beyond the double doors at the entrance to the department there are displays of timetables, pupil lists, group movements, details of department meetings, vocational information, reminders to staff, and information on local exhibitions. A low table set in the middle of some chairs displays printed syllabuses and brochures setting out the department's objectives and intentions. The document which deals with aims and objectives is well-designed and professionally produced. The introduction to the syllabus contains a statement by the head of department about the sort of art education that his department encourages. This is followed by an outline of the course

45

year by year. It includes examples of grading lists, work-sheets, homework samples, history of art activities and simple exercises with pen, ink and colour.

A discussion with the head of department revealed an interest in developing his team to his own level of commitment as well as introducing the children to a system which they could use to achieve their own ends.

"My teaching may appear to be highly systematised but most pupils need a straw to clutch at and I provide the straw. I try to inculcate feelings of industry rather

Below School 13
Pupils have access to the syllabus, lesson notes and other records in the art dept. office.

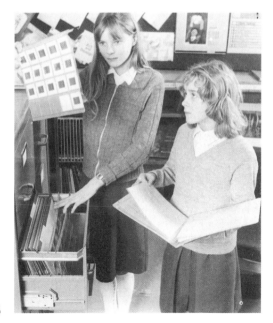

46

Above School 13, 5th year

than indulgence. Commitment is vital, and the importance of good organisation and communication is instilled through formal minuted staff meetings every week. I make notes after every lesson I teach and these are referred to in meetings. I encourage my team to make similar notes and an amendment file is kept for examinations and in order to review the syllabus. Careful grading and reporting systems are kept for all children, with photographs attached from the fourth year onwards, and all staff including part-time teachers can take from it and add to it."

The value of such a system was demonstrated by a supply teacher, who had been working in the department for only a few weeks. She had found it simple to use the carefully structured system created by the head of department. She could refer to the written structure to find out what they had done and what they were aiming for, and could use her own strengths and enthusiasm to similar ends.

The ability to organise thoroughly is also seen in the head of department's art room which is extremely well ordered; venetian blinds drawn against a low winter sun, a wide variety of prints and carefully labelled displays of printing techniques decorate the walls; lino tools are numbered according to size and placed in numbered tins; rollers hang from a frame erected to dry prints and a special set of plastic rollers are set apart

School 13, 5th year
Wax-resist technique is used in this interpretation of irises.

clearly labelled 'for oil inks only'. Bench hooks are used to cut against with safety and screens are carefully covered except for the parts worked on. A bench, equipped with three right angle registration frames to locate screens, also allows adequate spaces between for materials and equipment. A screen-printing table, home-made from proprietary steel angle, is being used as a second printing station. Cutting, drawing, printing activities are well separated. There is no room for a print drying rack, so strings of bulldog clips are improvised over a work top.

This department has been able to convince the school that practical work is more effective with smaller groups. In the first three years therefore, three classes are timetabled together and are divided into four groups with four teachers.

The thoroughness with which work is prepared is demonstrated by the material used by teachers and pupils. There are well produced books of project briefs, such as the one on packaging seen in use with a fifth year group, and another on symbols, graphics and animation. These are reinforced by a carefully devised series of worksheets and workbooks.

All the schools described take care over the monitoring of pupils' progress and many examples of good practice in this field were seen. One example, which is referred to in Chapter 7, includes written comment on the outside of each pupil's folder of work.

School 13, 4th year
Printmaking by silk-screen.

School 13, 1st year
Composing in three dimensions.

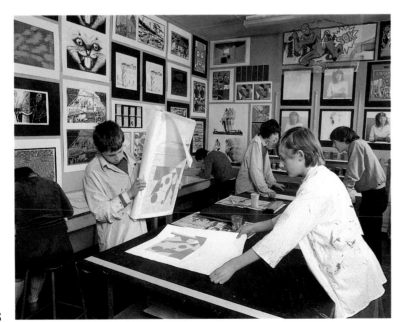

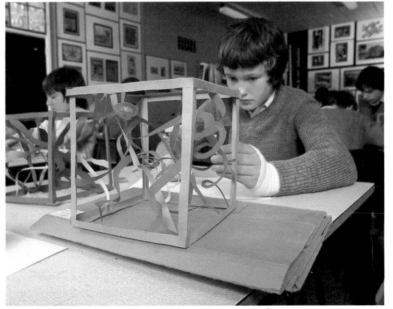

School 13, 4th year
On-the-spot drawing; a study for a lino print.

School 13, 5th year
An etching with aquatint.

Another example, in school 2, uses a list of criteria for assessment. Here the art department has a policy of assessment, designed to summarise individual pupil's progress and achievements under seven headings, which have been carefully related to the aims, objectives and content of the course. Two written records are kept on each pupil. One is completed every term and records effort and attainment on a five point scale against a checklist of areas of art, craft and design experience, such as observational drawing, colourwork, three dimensional work. The other record is completed at the end of each year and notes the pupil's competency under seven headings. Ratings are given on a five point scale and there is additional written comment. The criteria selected by the department are themselves interesting as are the characteristics described for each point of the scale.

The seven headings are:
Interest and enjoyment
Practical skill
The ability to express ideas visually
The ability to make aesthetic judgments
The ability to observe, record and interpret
The ability to transpose from two to three dimensions and vice versa
The ability to work cooperatively

The guide reproduced overleaf is used by the staff of School 2 when completing each pupil's record card. Written reports given to pupils and parents are in the form of generalised statements derived from these criteria.

Staff guide for completing pupils record cards (School 2)

INTEREST AND ENJOYMENT	A. Always shows a great deal of interest and involvement, is lively and curious, open to experimentation.
	B. Shows interest in creative activities.
	C. Is reasonably involved and motivated but without a great deal of enthusiasm.
	D. Is difficult to motivate.
	E. Appears totally uninterested in creative activities, needs to be pressured, sees no point in creativity.

PRACTICAL SKILL	A. Handles tools and materials with confidence and skill. Is able to select and modify.
	B. Handles tools and materials well. Is capable of working independently.
	C. Average ability but needs time to assimilate new skills.
	D. Lacks confidence in handling new tools and media. Needs much guidance.
	E. Is clumsy, lacks manual dexterity and is unable to work without supervision.

THE ABILITY TO EXPRESS IDEAS VISUALLY	A. Expresses him/herself fluently with imagination and flair. Has an abundance of visual images and the ability to communicate the same.
	B. Has imagination and works steadily and is able to communicate in visual terms.
	C. Needs help and encouragement in order to bring out ideas in visual form. Lacks flair.
	D. Has great difficulty in putting down ideas. Has no confidence in ability to express him/herself visually.
	E. Is totally lacking in imagination. Seems incapable of expressing anything of her/himself visually.

THE ABILITY TO MAKE AESTHETIC JUDGMENTS	A. Can bring to bear, within practical, written or verbal work, informed judgments and sensitive response to things requiring the same. Can understand subtle qualities.
	B. Is well able to make decisions, judgments and give opinions which show some thought and awareness of an aesthetic response.
	C. Has an average level of aesthetic response on practical, written and oral work. Lacks ability to use previous experience in making judgments.

D Fails to respond sensitively and use informed judgments in practical, written or oral work.

E. Has no real opinions which show awareness and sensitive response. Gives no hint that is able to respond with feeling. Lacks aesthetic awareness. Is blind to subtleties.

THE ABILITY TO OBSERVE, RECORD AND INTERPRET	A. Observes with accuracy and skill. Can see and record all relevant details and if necessary select. Is alert to pattern structure etc. Sensitive response.
	B. Can record accurately and well. Has some ability to respond sensitively and selectively.
	C. Can record with reasonable accuracy but lacks a great deal of flair and feeling response.
	D. Is lacking in ability to record well either with a seeing eye or sensitive appreciation.
	E. Is unable to record what he/she sees. Either cannot see or cannot make the hand/eye co-ordination. Observes habitually without any sensitivity.
THE ABILITY TO TRANSPOSE FROM TWO TO THREE DIMENSIONS AND VICE VERSA	A. Can immediately see how an idea can be transposed successfully from one dimension to another.
	B. Has reasonable success in taking an idea into different dimensions.
	C. Is moderately successful in working ideas from $2-3$ or $3-2$ dimensions. Needs some guidance.
	D. Has difficulty in seeing how an idea can be worked through from two to three dimensional media unless is given much help.
	E. Is totally unable to use an idea or theme from one material or dimension to another.
THE ABILITY TO WORK COOPERATIVELY	A. Can work extremely well in a cooperative situation, either in a minor or a leading role. Is helpful and sensible. Can organise.
	B. Works well in a cooperative situation where work, ideas, materials have to be pooled.
	C. Works reasonably well within a group.
	D. Is inclined to let others do most of the work. Tends to opt out in cooperative situation.
	E. Takes advantage of the situation. Is a nuisance, interferes with others. Fails to understand the needs of others. Unable to work in a team.

These are all *broad* categories and need not be expanded further by adding + or −

School 14 The art department from the reference area.

Chapter 7 "I live here!"

The art department of school 14 has four art rooms converted from a gymnasium and changing rooms. A high-ceilinged area has been made into two studios and the lower changing room section has formed two more, which are lit from above. All are inter-connected spaces, meeting in the centre in a books, study and information area which contains a collection of books on art, photography, design, textiles, crafts, furniture, architecture and books of general visual interest. There are also art and design periodicals, leaflets and posters. Each year £200 is spent on books; they are an important element of the display in the studios. Some of these are selected for their relevance to current work; others are about specific crafts taught in the department.

In the studios, shelves hold an intriguing mixture of plants and other objects, painting equipment, containers of materials for crafts and under work tops are boxes of fabric off-cuts and scrap materials. Examples of constructions and silhouette work hang from the ceiling. On the walls, which are hessian-covered and spot-lit, are carefully mounted displays of current two dimensional work.

In another room, used mainly by a part-time teacher, what is on show emphasises that she specialises in screen printing. There is a sectionalised cut-out representation of an Egyptian figure in white mounted on black and some collage studies of shiny spherical Christmas-tree decorations with the highlights applied in metal foils. There are patterns based upon pen-made letter forms and screen prints of drawings from life which have been cut from paper stencils and printed in four or five colours. Other screen prints based on drawings include a drawing of a camera, a study of a training shoe printed on fabric in six colours, parts of a guitar, the end view of a mangle, a pattern of bicycles made by the repeated over-printing of a fine linear image. There are direct studies from sections of pomegranates, collections of bottles, draped fabrics, and self portraits in which the emphasis is placed on the analysis of the subject in defined flat shapes, in preparation for screen printing.

These staff have decided that the working environment is their most important teaching tool and have so arranged it that what is on show always has relevance to the work in hand. Speaking of the importance to her of the working environment a teacher says, "I live here. This is where I am for most of my time. I find these surroundings important to my own life. This environment so often acts as a stimulant or reinforces learning; even small things can be so potent". She is honest enough to add: "But even so on some days everything falls comparatively flat".

At breaks and between lessons pupils of the lower school find the display of great interest, identifying their own and each other's work and commenting privately and more critically on the work of other pupils. Away from the active presence of their teacher they reveal a continuing concern with evaluation. The presence of their work in their own school environment gives them an opportunity to evaluate their contribution. They discuss such matters, when evidence is to hand, with the same forthright vehemence with which they discuss football and pop records and, provided they hear it, as they do at this school, they eagerly acquire an appropriate vocabulary.

A number of well-tried assessment procedures have been adopted and refined. The work of each pupil is kept in a large folder and they have frequent individual tutorials during lessons with the teacher, when the work is reviewed and the pupil is helped to know and understand his own working method. Pupils are encouraged to discusss how ideas have emerged and been developed. On the outside of this folder the teacher, and sometimes the pupil, makes notes on the main points of the tutorial. These comments are quite informal, useful in a practical way and may include an assessment grade. Finished work of quality is removed from the folders and stored

separately. At the end of the fourth year each pupil is given a detailed criticism of the work done, in which their strengths and weaknesses are noted. In the fifth year, these strengths are developed through increased specialisation. The strongest work is identified and analysed as a matter of course. Markings are decided by discussion and are used diagnostically to help pupils understand their strengths and abilities and how they might develop. Group discussion is important in, for example, looking at homework. They develop a critical vocabulary and an understanding of criteria and do so quite early in the course. In the fourth year the assessment is indicated by a percentage recorded on the folder. In the

School 14, 4th year
A pencil/crayon drawing.

fifth year grades are given on a five point scale which reflect O-level and CSE procedures.

The head of department says that the pupils learn through close observation both within and outside the studio. Simple strategies are used to heighten visual awareness, for example first year pupils look closely at the shadows made by daylight and artificial light on three different, apparently 'white' papers and note carefully the subtle differences in colour. Pupils are frequently confronted by images from the past and the present; the work both of artists and pupils of the school and they learn to value and enjoy these experiences. Discussion is seen as an important feature of learning and places emphasis on developing a perceptive response. Enjoyment is not neglected and

this, together with sophistication, vitality and the expression of personality are thought to be important aims.

The importance of discussion is exemplified by a lesson seen in which a third year group work from succulents and cacti. First, the teacher talks about a single plant in terms of planes, colour and tone; pupils being inevitably led to use the correct, specialised language and to understand what it is they see:

"Notice the tone and colour changes where the form turns away".

"Take a section – don't try to do it all – and take the end of your chalk – use nice sweeping movements. If you can

School 14, 4th year
A pencil drawing.

School 14, 5th year
Drawings using pastel.

make it large enough you can let it go off the paper".

Ten pupils intending to work in clay are helped to interpret the plant form in the medium.

"How can we give an impression of how the plant is constructed in clay? Can this be a feeling about it rather than recording the whole plant exactly as it is?" Then the teacher took some clay, and worked with it as she spoke. "I will start with a small round stump then add the sections. Next, what shape do the sections make?" "A spiral". "A coil".

She went on discussing how one might construct the "essence" of the plant and describe the nature of the form seen. "It reminds me of a star fish" said one pupil. The teacher quickly gets out a good specimen of a star fish and it is examined to see the similarities and differences. The group are closely interested in this collective analysis in clay and how a plant can be interpreted in the medium. Technical matters are not ignored. As she uses the clay the teacher shows them ways to shape it and how to use brush hairs to represent the spines and observe the direction in which they point.

"Start off by breaking it down into its basic shapes. Just look at the lumps and bumps and wrinkles".

As the work develops, the teacher encourages critical looking at what has been done. Of a clay shape she asks:

"Is it even? Is it smooth? Is it neat? Compare what you have done to the form you are looking at. If you are in doubt about modelling any particular section,

55

get some scrap paper and chalk and sketch it out. You can break it down into sections in two dimensions".

The teacher moves round the class, looking carefully at the work and discussing it with the pupil. Later she interposes with a fresh stimulus; picking up a ceramic sculpture from a table and saying , "Oh, I meant to show you this – it's by a sculptor called Alan Heaps.

See, it's rather like the work you are doing. It reminds me of waves. The little forms here are almost like your cacti. Do you want to see another one?"

She picks up a second sculpture while pupils handle the first, saying

"Many different ideas have been put together to make one piece".

A boy says, "it is a sort of fantasy image". Another mentions Alan Aldridge's drawings, and yet another mentions a cartoon film using similar imagery.

When the class has cleared away and left the studio, the teacher begins preparing a working display for her next group. She has already collected together everything needed, but now sets to work to section fruits and vegetables accurately and thinly with a sharp knife. They are laid out on individual pieces of paper, of a colour showing them off to best advantage. For example, cucumber is cut diagonally, forming elongated ovals, and arranged on small oblongs of black paper, which darken the transparent material surrounding the seeds thus clarifying the structure.

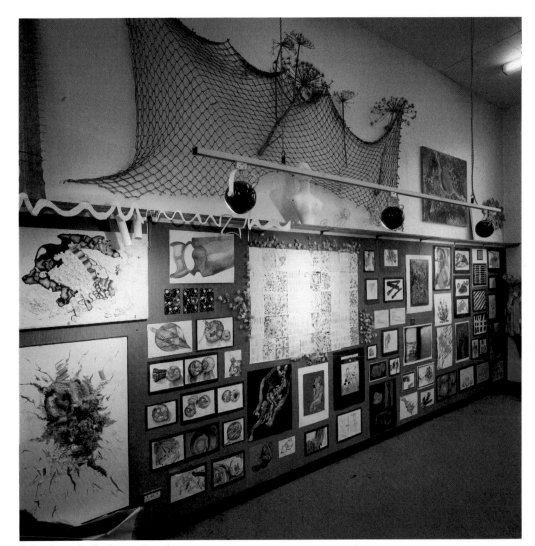

School 14, A display wall

The head of department is teaching a fifth year group. Each pupil is working on his or her own programme. Howard is working on an oil painting about four feet by two-and-a-half feet of a landscape with a large area of water in an unusual light and buildings and land in the background. He has a group of colour photographs, which he had taken himself, for information. He talks freely about his work. "I haven't worked from a photograph before. I am not copying it of course, I am using it for information about the forms of ripples on the water. I am enjoying using oil paint. It is so flexible in the ways in which it can be used. I have tried acrylic but think it is rather difficult to use because of the way it dries. I have my own oils at home". He is using colour to establish space as well as to describe the subtle forms

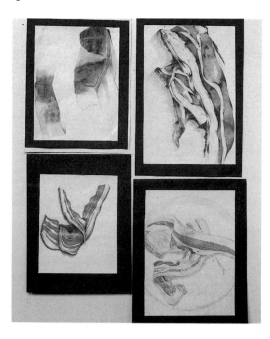

School 14, 4th year
Drawings done for
homework using oil
pastels and coloured
pencils.

of surfaces. The tone pattern is strong and he is concerned with the balance of the design. At the same time another teacher works with a fourth year group. These pupils are thought not to be very able academically, nor strong in other subjects. In art, they are performing with confidence. Alan is making a twelve inch square three colour lino print of a ram's skull. His last piece of work was larger-than-life-sized painting of a knotted tie, carefully observed and skilfully painted. Richard has completed a sensitive painting of a snake skin, and now turns to his current interest in motor-cycles to produce a picture. The teacher accepts this and is able to use the interest as a basis for teaching. Others draw and paint from landscape, the figure, animals and objects selected from a special display. A plant, pieces of bark and a jar of water containing crumpled sweet papers may lead to a print, a painting or a fabric. Each pupil did a set of enlarged drawings of spherical harness bells earlier in the year, which took about six weeks to complete. These are evidence of surprisingly concentrated looking at form and tone. The young teacher is confident of her pupils' capacity, makes no allowance for their supposed lack of academic ability and demands high standards. Further, she takes real pride in their achievements.

Meanwhile, in the next studio the fifth form group is still working. One pupil is engaged on a photographic study of vandalism and graffiti. Another, who has made a graphic study of letter forms, is now developing a card relief interpretation of it. Not all pupils are versatile, and some work quite narrowly, but they are conscious of developing their own strengths. According to the teacher they are neither artistically nor academically able. A number of pupils are being very strongly directed by the teacher and accept this happily. They seem to understand why they work as they do, as well as how they produce their work. The pupil using photography returns having taken 15 photographs. He will complete the roll of film outside school this evening. His immediate objective is to produce a set of photographs; not seeing further development at this stage, but the possibility of a tape slide sequence was discussed. The day ends with an informal and mature discussion of work between pupils and teachers. The happy, relaxed but purposeful, working atmosphere of the studios is maintained beyond the end of the school day, as pupils stay on to talk, or return to check on work or continue with a painting.

The following day a number of first year classes have their art lessons. One group of pupils concentrates their looking by masking in paper an area of a piece of gnarled wood or bark in the same ratio as the A2 paper they are going to use. They have been asked to start their drawing from the centre and work outwards. This part of the programme is one in which they have considered colour and used this in a drawing from hair. They are

keeping their tone work and hair drawings beside them while working from the bark. Eyes occasionally move to the displayed work. They appear to see how similar problems have been solved by others, and they discuss how this has been done.

In a previous lesson another first form group has prepared what the teacher called 'ideas sheets' in which they had explored the qualities of marks which it is possible to make with a pencil using its tip and its side; sharp and blunt, hard and soft, making fast and slow movements and with variations of pressure. They had then been encouraged to relate these qualities to the problem of drawing selected sea shells. In returning this work to them at the beginning of a new lesson, the teacher looks closely at each pupil's drawing and emphasises the need to refer constantly to the ideas sheet to find an appropriate means to describe the qualities discovered in the shells. She emphasises the need to discover non-linear aspects of their form and to find a way of seeing and representing what is to be found between the lines. They are to avoid what she calls the "lace curtain effect".

This guidance is given not so much to influence their drawings, as to direct their seeing and it results in this case in sustained concentration and is intended, as the teacher explains, to ensure pupils' success in representational drawing early in their school career. As an aid, pupils are encouraged to examine parts of the shells through cardboard viewfinders to eliminate confusion between what they see and their expectation of what a shell is 'supposed' to look like. In explanation of her method the teacher makes an analogy with language saying that the more words you know the more things you can say and the more you can say the more you are able to see. She then relates this to the vocabulary of marks they have developed.

This habit of recapping on the pupils' experience of a previous lesson is one established by the head of department. With a third year class he reminds them that they were introduced last week to the medium of oil pastels and invites them to sit round and near to his desk. They form a comfortable group, some sitting on stools, others on benches so that each has a clear view of the teacher's desk on which there is a collection of their work arranged on sheets of red paper. He begins by asking them what had been enjoyable about using oil pastels. They reply that they had been able to make strong colours and that they do not smudge easily. He asks whether these properties are advantageous or disadvantageous. One pupil responds with the suggestion that they can be either good or bad depending upon the effects required. Amongst the favourable suggestions now made are the blending of tones, the gradual change from one colour to another and variations of density achieved by variations of pressure. A pupil says, "You get opaque". "What does opaque mean?" There follows a discussion on the meanings of the word with reference to the use of transparent and opaque surfaces in domestic architecture and car design and a consideration of the effect of using opaque or transparent pigments which might be used in painting on a strongly coloured ground. As the dialogue develops the characteristics, advantages and disadvantages, of the pastels are identified by the pupils from their experience. The teacher draws out ideas and helps the pupils to sharpen their comment. The pastels themselves and other media are used to make marks to clarify what is said.

The teacher in this way uses conversation with particular pupils to make a point for the whole class and to render them articulate about the experience they are undergoing and the learning which is taking place. This engenders a group's enthusiasm and it is common for pupils to work through breaks and lunch hours to take work to the point where they are prepared to leave it.

The headmistress says that in her school art is a subject which encourages pupils to make individual responses and reactions to experience and she sees this as crucial for their development. The range of skills which the staff bring to the department provides pupils with the choice of a number of art activities according to their abilities and interests. She thinks that pupils in the school reach their potential in art and this is true for many who experience failure in other subjects. She also sees the subject as important in a career sense for some pupils, and for all in offering a pursuit which will continue as an important part of their everyday life. The subject is pursued at lunchtime and after school and the pupils appear to value what they do in art. The head observes that they are made to work tremendously hard.

"They say they really enjoy this labour. It amazes me how much they get through in their art lessons".

Chapter 8 Conclusions

Pupils

There is no way of knowing what the long-term effects of the pupils' art education will be. However the pupils at work in these departments seemed to share certain characteristics. The first of these was a confidence that their views were respected and their needs anticipated. They were not surprised to be consulted and appeared to meet the expectation that they would act responsibly. Respect for each other and the practical demands of working together appeared to provide an acceptable basis for self discipline while pride in achievement or in the development of demonstrable skills contributed to further progress. Pupils characteristically entered the room and started to work as one teacher put it, "before you've even had time to catch your breath". That sort of attitude he said, "where, in a sense, they feel that they are in charge is so pleasant to work with. The work progresses continually". An evident support to such initiatives was the security which pupils derived from their sense that their teachers knew their business. The teacher's expertise set the standard for appropriate social behaviour in a good working environment.

Pupils appeared to reveal their preferences readily and were able to discuss their feelings with a degree of objectivity when making judgments.

Following a period of unselfconscious concentration they were often surprised by their own achievement. Equally some had evidently learnt how to deal effectively with disappointment and to turn what might have been failure into a means of increasing their technical and aesthetic understanding.

Teachers

Not surprisingly, the most important factors in achieving good standards were the special qualities and knowledge that each member of staff brought to bear. There were a few teachers in the schools visited who, by force of personality, galvanised pupils into action and rivetted attention upon the job in hand. That sort of charisma, when coupled with sound organisation and appropriate expectations is a valuable gift. Few of the teachers were so gifted: the strength of the majority came from sound workaday professionalism.

Some elements of this professionalism are discussed elsewhere in this summary, but owe much to the confidence which teachers derive from their deep knowledge of art and design as demonstrated in their teaching skills. For example, most teachers gave clear and unambiguous instructions to their pupils whenever that seemed appropriate and had analysed the steps that pupils needed to take to master a skill or a concept. Lessons were often prescriptive in the early

stages of a new project, focussing on the major task or the core of the lesson. This seemed to allow more genuine individual freedom subsequently, being based, as it was, on an enhanced competence and understanding. This was particularly evident when one individual lesson was clearly seen as being part of a developing programme.

Many were prepared to demonstrate processes and to work with materials as an extension of their verbal skill in communicating with their pupils. Teachers shared their skills freely and were open in discussing their intentions. The emulation of the teacher which resulted, was part of the process of making pupils confederate with their teachers in a sense of shared enterprise.

This sense of shared enterprise, coupled with the clear evidence of the teacher's own commitment and enthusiasm, was one of the chief factors in motivating pupils but there were others, such as the teacher's awareness of the pupils' own interests, and niceties of judgments about change of pace or scale. For example, in school 5, pupils were seen working at one time on a 16-hour drawing on an A1 sheet of paper and, at another, working very rapidly completing a screenprint design on a length of fabric in a double period.

None of these departments was averse to teaching very basic skills, for example how

to use a roller to ink up a slab and transfer the ink evenly to a block. Such a skill can be taught in isolation, but many others, for example, the expressive range of a pen or pencil, although taught directly when appropriate, were normally embedded in projects which had other main objectives. This concern with simple yet important matters was seen most consistently in the teaching of drawing – the necessity of which, though widely accepted, poses particular pedagogical problems. For example, in schools 1 and 3, not only was the selection of objects to be drawn undertaken with painstaking care but great attention was given to the best angle and position for viewing and the most helpful lighting. This was supported by the teacher's willingness to help pupils focus their looking, and a readiness to provide tangible aids, such as view-finders.

One of the most important features of success seemed to be the character of the language used by teachers – the best was not only encouraging and motivating but also precise and illuminative. The description of subtleties of shape or colour, for example, helped pupils become more aware of these qualities and more able to search them out for themselves. Reflective and retrospective discussion in class was often a way in which this was achieved. The teacher's language was helpful in developing the ability of pupils to discriminate, characterise and judge for themselves.

Heads
In some of the schools the encouraging
60 influence of the head and other senior staff

School 11, 5th year A self-portrait.

was strongly felt. That support took many forms, but principally it was to do with active involvement and tangible improvements, such as good staff appointments, realistic capitation allowances, teaching groups of appropriate size and balance of abilities, and a reasonable allocation of time.

In school 8 the head's interest in graphic and photographic communication created just the climate in which his art teacher, skilled in these media, could prosper. In school 2 the head acknowledged that his appreciation had grown through observation of the work done and he saw it as vital that each child, at least in the first three years, should experience art. "I first learnt from the work in this department", he says, "what art education can mean. One usually sees a few talented pupils developing their gifts. What one doesn't see usually, but does here, is *all* children producing work of quality. There is a staggering amount of talk and response and children have a vocabulary for criticism and disscusion. That is why small groups of around 20 are necessary, bigger groups inhibit this".

The head of one school (14) considers art as important a subject as any other and values the way that art enables individual responses to be made by all pupils of whatever ability. The head of another (12) finds time to visit her art department regularly and to be sufficiently in touch with individual pieces of work to know about individual pupil's progress. She says that art is one of only a few subjects where pupils are enabled to be themselves, and to be given time to find within themselves a developing

sense of value. At another school (9) the head's guidance led the head of art and his staff to identify a core of essential experiences. This became the basis of a scheme of work with the advantage that it arose from the considered convictions and strengths of a group of experienced teachers.

In most schools senior staff gave positive and active support. There were, however, several schools where the encouragement given was mainly verbal and where the staff worked in difficult circumstances of relatively poor capitation allowances, large teaching groups, or option groups with a disproportionate number of less able pupils. Their conditions had apparently been depressed in order to maintain or improve those of some other subjects at a time of financial stringency. In the small world of the school they needed a robust attitude to operate to such high standards in face of being undervalued.

Organisation; departmental
As these descriptions of the work in some schools make clear, art education encompasses the use of many techniques and materials. The spaces, storage and furniture available only seldom fully match the needs of the pupils or the expertise of the teacher. However, art teachers are essentially practical and there were many examples of effective improvisation – cupboards being "rescued", racks installed, re-siting of equipment, and even minor building adaptations to create more useful space, as in school 9. The standard of accommodation and equipment is not the most important factor in obtaining quality of teaching and

learning, but it can do much to ease and uplift, or restrict and depress. The skilful teacher seems to know where improvisation is possible or whether some activities have regretfully to be eschewed. Whatever the art department is faced with, there is no doubt that meticulous attention to even the small details of the practical organisation of rooms, materials, techniques and time is seen by these schools as a springboard for effective teaching. For example, a number of schools (including 1, 4 and 14) were at pains to arrange a great variety of objects for study before lessons began; many (for example, school 4) made the storage of material itself an object lesson in visual order; most trained their pupils to get for themselves the materials and equipment they needed and to replace tools ready for the next user.

At a different level every art department in these schools was concerned to provide a clearly structured course, well understood by all members of the department – although not all wrote it out in detail. Many schools did and one had an unusually comprehensive written course of art education which extended to the provision of a departmental lesson file, from which all teachers worked, and work sheets and work books for pupils use. This reflected the linear approach of this department in which the stages of artistic competence were prescribed; by contrast another looked to a more organic and branching development and allowed for a wide range of individual growth. Not all agree with the "aims and objectives" model of syllabus construction though some departments did structure their intentions in this way. School 14

quoted and discussed alternative theoretical models as a preface to the department's syllabus. School 7 was able to set out its aims, after a period of much thought and refinement, with a deceptive simplicity and clarity and here pupils themselves were brought to an understanding by discussion of these aims. None of the schools was reluctant to see the development of a range of manual and discriminatory skills as a worthwhile aim, both as ends in themselves, and as giving access to artistic expression. All schools saw the thorough teaching of drawing as both a prime objective and a key which unlocked the door to a distinctive and convincing personal expression on the part of the pupils.

Schools were very different in the way they organised their art departments. In some, the head of department worked informally by persuasion, influencing his colleagues by example and by enabling the department to focus on past performance in order to establish long-term aims. In others the department was more formally organised with time set aside after school for minuted discussion on particular curricular topics. In one school the style was distinctly authoritarian with a working structure and norms of perfomance to which staff were obliged to conform. This was seen as acceptable by the staff because of the inspiring and dynamic leadership of a head of department who asked even more of himself than of his colleagues. Whatever the style much discussion was usual within the department and was in itself a form of staff development.

Organisation; school
Clearly the way in which the school as a whole was organised affected the running of the department and what it could achieve. For the most part, the schools described had an orthodox arrangement of at least two periods per week for the whole of the first three years and not less than two double periods each week for those studying the subject as an option in the fourth and fifth year. During the initial period of visiting, a number of schools were seen which in years one to three operated a rotational scheme with other subjects. The fragmentation of experience created by the rotational arrangements was often coupled with less than the minimum necessary amount of time and in no case were standards of work sufficiently developed to warrant inclusion in this publication. It seems, therefore, that regular and continuous contact with the art department is important if satisfactory standards are to be achieved. All the schools operated an option system which enabled pupils from the whole ability range to take art until 16, although in some cases pupils were confronted with option choices which inhibited the study of art by the academically able.

All the schools visited had appropriately qualified specialist staff, many of whom had been given roles outside their art and design responsibilities. The most usual qualifications were those from colleges of art and design, followed by postgraduate art teacher training.

The pupil/teacher ratio operating in art varied considerably between schools. This was found to affect the nature and range of activities rather than the quality of work. Not surprisingly, departments working with groups of more than 30 pupils placed less emphasis on teaching the crafts. Shortage of money had also generally led to a narrowing of the range of activities, rather than a deterioration of the quality of materials used for the work which was done.

Organisation; external
The effect of LEA advisers in some of these schools was marked, through advice on appointments, staff development programmes, and general support and encouragement. In a school in a small Authority, the art adviser had, with the help of a strong part-time teacher, held the art department together during a period of staffing instability. Some schools contributed to LEA exhibitions of pupils' work, which were another means by which advisers set high levels of expectation. Advisers provided a focus for curricular discussion, and through their contacts with other advisers in their region, disseminated good practice. Although not all the schools described had contact with advisers, HMI were in no doubt about the value of active art advisers in raising standards in their Authorities.

Assessment
Teachers regarded the need to assess progress and record what was done as crucial, although the methods used varied considerably. Discussion and assessment while work was in progress was the method favoured by school 7. This gave the teacher the opportunity to set work in a wider

context and to develop the skills of discourse about artistic activity. The second occurred during discussion, as in school 4, of the collected work of each pupil. Judgements were made about the stage of development reached and were used as a diagnostic tool to prepare for future work. The third kind of assessment observed was that of pupils' judgments about their own work. This kind of critical ability springs, as indicated in Chapter 5, from a variety of factors, in particular the teacher's skill in encouraging pupils to examine their own work continuously. Pupils more readily alter, or even abandon work when, as in this school, they work freely and with confidence, rejecting the unsatisfactory pot or re-working a painting. External assessment, in the form of public examinations, was something which, on the basis of a soundly constructed and progressive course, most schools took in their stride.

These teachers were concerned to evaluate their own performance regularly, often with the help of other teachers' observations. Some, as in school 12 made notes after their lessons and used them as a basis for departmental discussion. Such discussions were part of a continuous process of reviewing the syllabus.

Most schools were systematic in their assessment and recording of the progress of each pupil. School 2 had identified seven criteria for pupil assessment, each of which was graded on a five point scale. the

School 2, 4th year
A portrait of the pupil opposite, observed closely and painted directly.

characteristics of each point on this scale were clearly defined and properly employed by the department.

Display and ambience

Display is sometimes used to further the public image of the department or school and although this is a useful role, it is far from being the only one. The schools described used display primarily to stimulate ideas and reinforce activity, informing attitudes about art and design experiences in the school and introducing propositions about its purpose in the outside world.

There were many displays, attractive in themselves, but also serving to help children focus upon a starting point. The resulting work was in turn carefully mounted or placed strategically alongside the source to create a sequence from tentative sketch to refined statement. This method of displaying served as a useful teaching aid, showing pupils alternative ways of working and possible standards of achievement. There were working exhibitions of materials and ideas which pupils took from and contributed to; they were explicitly arranged to support discussion and aid motivation and were not set pieces.

Displays outside the art room were often changed to demonstrate various activities and to show that the school valued its pupils' work. In some cases however the sense of quality valued in the art department ran against the grain of the school and its environment and it was difficult for the art teachers to instil and promote this quality throughout the school.

The art teachers described created a special ambience in their studios through knowledge of their subject and interest in their relationships with children. They were able to make ordinary classrooms busy with activity while the walls advertised pupils' achievements and surfaces reflected good studio attitudes. Attractive objects to handle, observe, rearrange and focus upon were everywhere and discussions about interpretation could be verbal with the teacher, or visual through displays. Pupils seemed to know how best to contribute to the ambience by the way they organised themselves and set about their own work.

In most schools visited the influence of the art department upon the whole school was marked and recognised. The art studio was often too small to contain the ideas and activity generated, and work overflowed into corridors, dining rooms, halls and foyers. In two schools particularly (12 and 13) strong links with the community had been established through exhibitions and the successful completion of several commissions in public buildings.

The nature of art education: the principles behind the practice

It will be clear from these descriptions that the subject can be pursued by means of great variety of activities; which is not to say that it is necessary to pursue many different activities in order to have a good course. The principal aims can be achieved through a concentration on one or two activities, and wise teachers on the whole work from their own strengths. What happens in an art room can be roughly grouped into making art, learning about art and learning from art.

The purpose of these activities is widely misunderstood. It is not to train skilful painters, printers, potters, graphic designers, industrial designers or knowledgeable historians of art and design, although these may be happy byproducts for the specially talented or motivated. Nonetheless these activities have very considerable vocational relevance: the range of practical competencies they require, the constant practice in judgment and discrimination they necessarily entail and the confident and articulate expressions of those judgments are valuable qualities in any context.

What marks the particular contribution of art and design to the secondary curriculum is that it emphasises the skills and understandings rooted in the senses of sight and touch, as well as in feeling and intellect. The chief concern of successful art and design teaching is to provide pupils with tools, practical, sensory and intellectual tools, by means of which they can become more of a person and make more sense of their experience. What are these tools? They include a range of skills, not only those manual and practical skills normally associated with the word, but the skills of acute perception and of effective discourse; they include knowledge: knowledge of the cultural and historical inheritance of which they are a part. Above all, they include a growth of artistic and aesthetic sensibilities and the personal values attached to them.

Pupils will vary in their ability to acquire these tools and there is no one 'right' way of helping them to do so. Teachers place their emphasis variously on giving primacy to

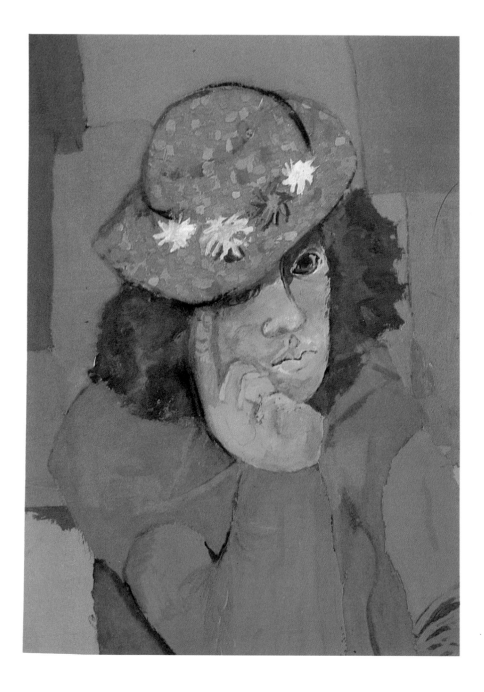

visual literacy, to problem-solving, to creativity, to being able to communicate effectively through visual means, to learning through a variety of visual cultural traditions or to various combinations of these sometimes different aims. Some teachers emphasise the interrelationship of aims, such as that between the importance of individual expression and the skilful use of materials.

There is no doubt however that there is evidence of a change in thinking about the balance of the art curriculum. Many of the schools described here, while producing artefacts of great quality, also lay stress on the need to educate their pupils to know about the work of other artists and designers both past and present and to be articulate in the judgments they make about them. They encourage their pupils to be critical of the visual qualities of film, television and other contemporary media, and to relate their developing sensibilities to the world outside the art room. These extensions of the art curriculum are not necessarily brought about by abandoning or limiting practical work but may result from projects which look for outcomes which are both instrumental *and* expressive.

However, whether associated with some further purpose or not, the making of artefacts is a major activity in our schools and involves a constant exercise of choice on the part of the pupils. They have to decide which material, colour, process, size and so on to choose. In this sense all lessons in art

School 2, 4th year
Half the class took it in turn to dress up and pose for the other half.

are lessons in designing, whether for utility, as when a pupil makes a jug, or prints a length of fabric, or (as in the case of a painting) for the good of the work itself and of its executant who proceeds, by likes and dislikes of form or colour, until a sense of personal satisfaction and achievement is realised. Few activities are as concentrated and fruitful in inculcating a sense of quality and style.

The contribution of art to design education is fully recognised in, for example, the Design Council's publication, *Design in secondary education;* it is less often recognised by others who confine art to an expressive role, failing to see the intimate connection between the effective expression of ideas or feelings and the necessity of designing for that end.

In art lessons such as those recorded in this book, pupils are encouraged to think inventively, to acquire manipulative and perceptual skills, to form visual images and to develop critical judgment. They learn something of the power of visual modes of communication and the ways in which these complement words and numbers. Art is not the only activity which draws upon these abilities and understandings but it is a particularly powerful medium for their development within the school curriculum. It has been the purpose of this book to show how that is achieved in some secondary schools.

School 9
A set for "Fiddler on the Roof", designed, built and painted by pupils.

Printed in the UK for HMSO, Dd736071 C100 3/83